A Different Kind of Order

The ICP Triennial

Joanna Lehan

Kristen Lubben

Christopher Phillips

Carol Squiers

DelMonico Books • Prestel | Munich London New York
International Center of Photography | New York

Published on the occasion of the exhibition *A Different Kind of Order: The ICP Triennial*, curated by Joanna Lehan, Kristen Lubben, Christopher Phillips, and Carol Squiers for the International Center of Photography.

Exhibition dates: May 17–September 8, 2013.

Published by the International Center of Photography and DelMonico Books, an imprint of Prestel.

◐ International Center of Photography
1114 Avenue of the Americas
New York, NY 10036
www.icp.org

Prestel, a member of Verlagsgruppe Random House GmbH

Prestel Verlag	Prestel Publishing Ltd.	Prestel Publishing
Neumarkter Strasse 28	14-17 Wells Street	900 Broadway, Suite 603
81673 Munich	London W1T 3PD	New York, NY 10003
Germany	United Kingdom	tel 212 995 2720
tel 49 89 4136 0	tel 44 20 7323 5004	fax 212 995 2733
fax 49 89 4136 2335	fax 44 20 7636 8004	sales@prestel-usa.com
www.prestel.de	www.prestel.com	

© International Center of Photography

ISBN 978-3-7913-5314-2

Director of Publications, ICP: Philomena Mariani
Production Manager, DelMonico • Prestel: Karen Farquhar
Design: Maya Peraza-Baker
Printed in China

Cover photo: Shimpei Takeda, *Trace #7* (see page 187).

Library of Congress Control Number: 2013934361

Table Of Contents

Out of Order
Director's Foreword

"The modern world is full of voices," cries a master craftsman in the face of the accelerated technology depicted in *Things to Come*, the prewar filming of H. G. Wells' prescient novel. A multiplicity of voices is just the point of the exhibition *A Different Kind of Order*, which also suggests a vision of things to come. Though, unlike the unified movie set of an elaborate sleek machine-age city of science fiction, it projects many possible worlds, sometimes jarring or subtly coexistent, rather than a fantasy in which we are delivered wholly from the past through a fantastic device, a market, or a changed political regime.

The vision of control in a single universal voice was recast fifty years later in Ridley Scott's iconic 1984 Apple commercial predicting the demise of Big Brother, here standing in for IBM. The sledgehammer hurled heroically before a Super Bowl audience did shatter the huge blue screen, but the prediction of an immediate and total revamping of cultures did not occur (any more than the entirety of the predication of Orwell's book keyed to the same date). Similarly, today an aerial view of Mumbai traffic shows black Mercedes next to bicycles and buffalo carts, each with the same glowing Vodafone in use.

Technology moves quickly and art often prefigures the future, opening seams for unknown conditions to be envisioned. The evolution of the digital has sparked other means of production and a reconceiving of communications and the transfer of information. The role of the print,

the object, the archive has altered accordingly. The collection of work in *A Different Kind of Order* mirrors the conditions of image making today: artists using photography or video, photographers using film and TV techniques, exploiting tensions between the hand and technology, disciplinary categories, art and commerce.

We are especially attuned to the blurring of accepted notions of order in times of economic and social upheaval. The discourse on the image has historically reflected these transformations. Walter Benjamin famously wrote in "The Work of Art in the Age of Mechanical Reproduction" that the dual inventions of photography and film ushered in a new era and were the hallmarks of modernity. Writing in the 1930s in a time of menacing inversions in the social order, Benjamin asserted the political intention and uses of the image. The mass production and popular reception of the image changed the nature of culture but also repositioned the role of the artist and image making.

Much has been proclaimed about the explosion of media and information exchange at the cusp of the twenty-first century. The very nature of the image, its legibility and global presence, ensures its persistence in the political and commercial spheres. Easy access to the creation and dissemination of the image has moved it far beyond the boundaries of official institutions. This vast democratization of exchange is indicative of a shift that magnifies the status of the image proposed by Benjamin in the

1930s. The coexistence of traditional and multimedia work in a polyglot world in which the overtly international and the contemporary are coincident with local and historical vernaculars and codes makes for a more complex interpretive field of meaning. The paradigm shift of recent years— brought about by advances in digital photography and video, a proliferation of mobile imaging devices and image-based social media networks— demands an expanded consideration of Benjamin's vision.

ICP has a history of critical work at the intersection of political and artistic practice, illuminating how and why images are created, circulated, and received. *A Different Kind of Order* was conceived amidst an eruption of social and political movements—Occupy Wall Street, the Arab Spring—catalyzed by massive economic inequality and government repression. Within this context, the image functions as a vehicle of communication, expression, reciprocity, social action. The exhibition reflects a dynamic point in history, grappling with fundamental changes in the medium and the identity of art and photography as purveyors of meaning.

The context for *A Different Kind of Order* is broad and the work operates at a variety of scales. The site is variously the body, the city, the landscape, the web and other ephemeral forms, and the work is realized through all manner of lens, monitor, and hand fabrication. The medium is the dye, the technological apparatus, and abstracts from and illustrates the world

through artistic leaps and analysis, bringing evidence from remote sites, or filtering daily life from a changed perspective. Like all profound creative offerings, it can suggest alternate readings of familiar scenes.

Long ago, literary theorists recognized the single narrative as a fiction, a very specific way of describing the order of things. Histories are constructed with much left out, at best, for the sake both of coherence and to shape a point of view. The creative work assembled in *A Different Kind of Order* was chosen to recognize the simultaneous and nonparallel versions of the world, the multiple story lines in which signs and meaning shift given one's standpoint. This is the hallmark of great work; it demands an engagement with questions. We are forced to reflect on what is comfortable and familiar and to find ourselves within various strands. Our sense of this depends on what we recognize as familiar patterns and cues, in the midst of a perceived chaos. It is perhaps more accurate to identify orders of a different kind—multiple ways of viewing a world in flux.

The 2013 Triennial exploits the proliferation of imagery in our networked world. It is an ambitious project that reflects the provocative framing by ICP's curators. I want to thank Curators Kristen Lubben, Christopher Phillips, and Carol Squiers and Assistant Curator Joanna Lehan for embarking on this venture. They have gathered an array of artists producing some of the most compelling work today. Together they articulate a range of factors driving current photographic production and set the stage for discussion and debate. I also thank Chief Curator Brian Wallis for his intelligent supervision of the project. *A Different Kind of Order* was made possible with support from the ICP Exhibitions Committee, Mark McCain and Caro Macdonald/Eye and I, Deborah Jerome and Peter Guggenheimer, Joseph and Joan Cullman Foundation for the Arts, Brown Penny Fund, and the New York City Department of Cultural Affairs in partnership with the City Council.

Mark Robbins
Executive Director

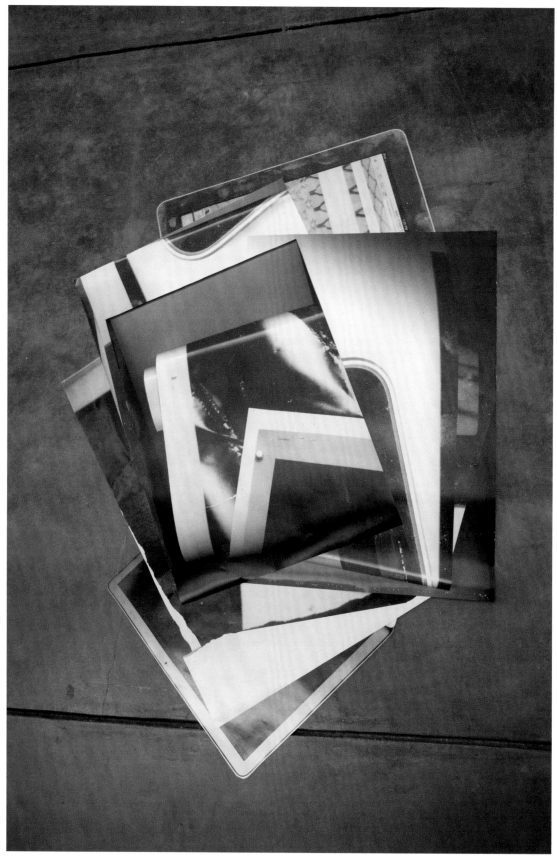

Andrea Longacre-White, *Picture of Pad Scan*, 2012. Courtesy the artist and Various Small Fires, Los Angeles.

A Different Kind of Order The ICP Triennial

When ICP's curatorial team began to discuss the direction that the 2013 Triennial might take, it quickly became apparent that the photographic world had changed dramatically since the exhibition was launched in 2003. The first Triennial, *Strangers*, conceived in the summer of 2001, became particularly timely in the aftermath of the attack on the World Trade Center towers on September 11, reflecting the air of anxiety and suspicion that came to pervade the urban social fabric around the world. Most of the works in the first Triennial were closely affiliated with long-standing photographic traditions and subjects. The street photographs of Philip-Lorca diCorcia and Beat Streuli; the classic large-scale portraits of Rineke Dijkstra; the more casual portraits of antiglobalization demonstrators by Joel Sternfeld—all could be seen as ultimately rooted in the documentary tradition, no matter how conceptually sophisticated or elegantly stylized the practice of the individual artists. It is perhaps worth noting, too, that most of the photographic works in that exhibition began life not as digital files but as film negatives or transparencies.

Looking back on that first Triennial produced a startling effect on the curatorial team, a sense of gazing on a quaint, vanished epoch. Today, digital imaging, triumphant and omnipresent, has driven film-based photography into a shrinking "analog" niche. Because still and moving images now inhabit the same digital platforms, artists and photographers move freely between still and full-motion processes. The circulation of photographic images now takes place mainly via the Internet, and billions of new photos are uploaded monthly on such social-media platforms as Facebook, Tumblr, Flickr, and Instagram. This profusion of shareable, essentially unsortable images has run in parallel with the erasure or reconfiguration of many old boundaries in the visual arts. In the 2013 Triennial, nearly one-third of the participants were born after 1980 and have grown up entirely in the digital era. For artists of their generation, mixing the quirky idioms of the new digital forms with the older visual language of painting, sculpture, and collage comes almost as second nature.

The ICP curatorial team began discussions about the 2013 Triennial in the summer of 2011. Still stunned by web-circulated images of the environmental catastrophe that had just devastated Japan, the unanticipated political revolution that was rapidly unfolding across the Middle East, and the ongoing collapse of global economic systems, we initially thought of calling the exhibition "Chaos." However, we became increasingly convinced that the present moment is not one of incomprehensible disorder, but is instead witnessing the emergence of a new kind of order, one shaped by identifiable social, political, and technological changes. The following short entries pinpoint some of the central points that characterize this "different kind of order" as it concerns the current situation of photography. These keywords provide a starting point for tracing the sometimes elusive connections that link the disparate styles, subjects, and formal experiments evident in the works included in the exhibition. They sketch the contours of the new visual and social territory in which photography finds itself today.

Joanna Lehan
Kristen Lubben
Christopher Phillips
Carol Squiers

Analog

Faced with the ephemerality of digital photography, and especially the everywhere-and-nowhere quality of photographs on the web, conventional photography's tangibility is more and more palpable by contrast. As digital photography increasingly recasts analog as a niche or alternative process, artists are able to employ analog's unique properties—its materiality and link to a specific time and place— as a conceptual strategy.

In an environment of increasingly dematerialized digital images, Jim Goldberg's monumental wall installation *Proof* invokes analog photography's capacity to serve as a physical trace of a moment of exchange between two people. The work includes over 600 portraits of refugees and migrants in Europe that Goldberg met over the course of his nine-year project *Open See*. The portraits are contact prints, images made by physically laying photographic paper against a negative and exposing it to light. By their nature, contact prints have an intimate, physical quality; traditionally used as work

prints, they are handled and marked up with notations by the photographer in the editing process. In this project, both the artist and the subjects themselves have inscribed the prints with the stories of their dislocation. Evoking photography's status as evidence, Goldberg offers the work up as proof, "certifying the existence of these individuals who would otherwise be invisible" because of their status as undocumented immigrants.

Japanese photographer Shimpei Takeda also uses contact printing in his recent work on the Fukushima nuclear reactor meltdown. In this series, called *Trace*, Takeda exposes photographic paper to soil that was contaminated in the disaster. The radioactive material in the soil caused chemical reactions that appear as constellations against the dark background of the exposed paper. The physicality of this work (underscored by the title) has an almost forensic quality; like a laboratory test, the photograms function as evidence in a way that more straightforward images of the meltdown cannot capture. Takeda returns to analog photography's fundamental process—the reaction of chemicals and light on paper—to create an eerily beautiful and deeply disturbing document of environmental disaster.

This sense of photography as trace is also apparent in the work of another Japanese photographer, Sohei Nishino, in a series of idiosyncratic city maps that he constructs by hand out of thousands of original black-and-white photographs. The project

originated in a class assignment to edit his 35mm negatives from contact sheets. Instead, the artist was compelled by the overwhelming excess of images and turned to collaging them together. Determinedly resisting the omniscient satellite view of Google Earth or the anonymous surveillance of Google Maps, Nishino's *Diorama Maps* are, like a contact sheet itself, the physical trace of one individual as he moves through space and time.

KL

Artist as Aggregator

"Under network culture, the artist as aggregator increasingly replaces the artist as producer." With these words, network theorist Kazys Varnelis points to one of the key aesthetic offshoots of the digital image environment. Today's artistic descendants of the postmodernist "image scavengers" of the 1980s have both an incomparably wider field of images to plunder and web-based platforms for effectively organizing and globally distributing their image collections. Digital images of the highs and lows of world art, architecture, and design of all ages can easily be located, dragged from a search window to the artist's computer desktop, and sorted into folders. In addition to such historic images, social-media sites have enabled their users to record and preserve the minutiae of everyday life on a scale previously unimagined.

Facebook, which might be regarded as the world's largest photo library, currently hosts around 140 *billion* images uploaded by its users—roughly 10,000 times the size of the archive of prints and photographs held in the U.S. Library of Congress.

A small but growing number of artist-aggregators have begun to trawl different parts of the online image universe and post their finds on their websites, blogs, or Tumblr pages. While this development is still in its early stages, distinct approaches have begun to emerge. Some artist-aggregators, for instance, confine their image-collecting efforts to one obsessive theme. The Italian artist Chiara Corica, who in 2009 founded the Tumblr blog "Short Hair" as an outlet for what she calls her "fetishist passion" for haircuts, maintains a constantly growing collection of photographs of young women (and occasionally young men) with assertively short hairstyles. San Jose–based artist Doug Rickard, who launched his blog-style website "These Americans" in the same year, presents, without written commentary, a host of vernacular and documentary photographs that reflect the social and cultural ferment of the years 1950 to 1980. His own perspective on the period comes through clearly in the subject headings that he uses to organize his holdings, such as Celebrity, City, Crime, Culture, Guns, Industry, LGBT, Mugshot, Pinup, Politics, Prison, Protest, Race, Religion, Riots, Sex, State, War.

A more informal and intuitive method seems to underlie Vancouver artist

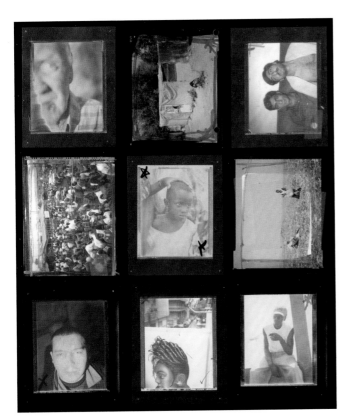
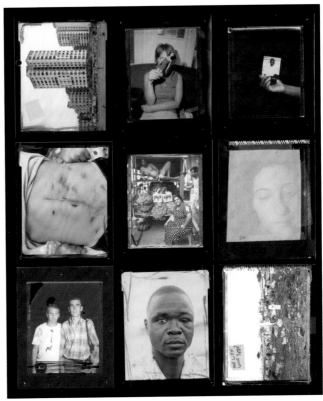

Jim Goldberg, *Proof* (details), 2011. Courtesy the artist.

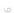

Roy Arden's blog UNDERTHESUN. Its 160-plus folders contain a wealth of images drawn from obscure corners of the visual culture of the past 150 years. Movie posters, book cover illustrations, crime scene photos, astronomical photos, shoe polish tins, anonymous snapshots, portraits of Andy Warhol, 1960s Fiat ads, early comic strips, publicity shots of David Bowie, homages to artists such as Malevich, Bellmer, and Hans-Peter Feldmann—all jostle for attention as the viewer scrolls down the blog page. Clearly related to Arden's own installations, sculptures, collages, and photographs, many of these images also reappear in his epic QuickTime video *The World as Will and Representation*, included in the Triennial.

New York artist Nayland Blake, whose practice involves installation works, sculptural objects, bookworks, and video, has been blogging since 2003. He maintains several different blogs with distinct functions, posting his daily mobile-phone photos, for example, on "A Mania, Blankly Willed." He sometimes uses his blogs as online visual notebooks, as spaces to accumulate images that aid him in creating installations or exhibition projects. His blog "Free!Love!Tool!Box!" contains a far-flung assortment of images related to his similarly named 2012 installation, which takes as one of its focal points The Tool Box, a legendary 1960s leather bar in San Francisco. Regular visitors to the blog were able to follow the development of the installation, and Blake's changing mindset, through the free-associational patterns of images—some historical, some contemporary—that slowly took shape there.

These examples are early signs of a direction that can only grow in sophistication as customized visual search capabilities become available. Trillions of digitized images are patiently waiting to be found and retrieved from cloud storage. The age of the artist-aggregator is just beginning.

CP

Collage

One of the most compelling aspects of artmaking today is the incredible variety of media and techniques used by many artists. This has particularly impacted the photograph as an object, with a surface that was once considered inviolable. Now that surface is often cut, abraded, penetrated, and otherwise worked into sometimes confounding forms that we can only group under the rubric of "collage." This kind of work may contain photographs and an array of mechanically reproduced images along with other media, including digital media, paint, canvas, metal, found objects, wood, sound,

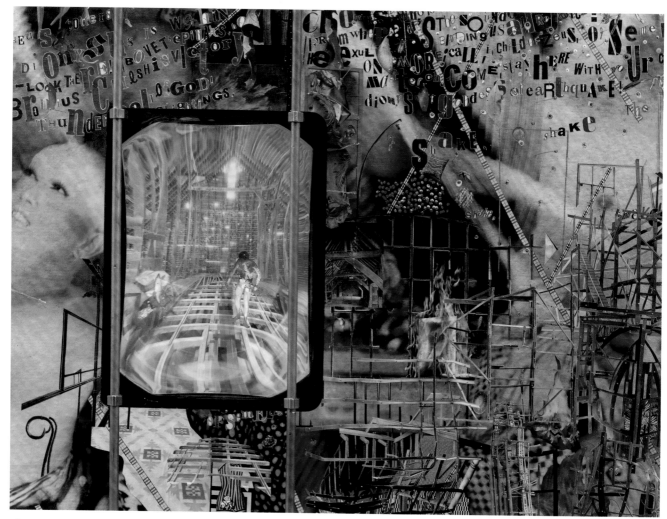

Elliott Hundley, *the high house low!* (detail), 2011. Courtesy Regen Projects, Los Angeles.

video, and film, all of which has combined to blast open and reconfigure the field of the photograph itself in exciting and unprecedented ways.

Cutting up photographs, newspapers, and magazines and reassembling them in an assortment of amusing, grotesque, sentimental, or critical narrative scenarios has been a part of Western visual culture since the invention of photography. Aristocratic British women in the 1860s and 1870s were among the most enthusiastic practitioners, often combining decorative or fanciful scenes done in watercolor and ink with portraits of friends and family, such as the United Kingdom's royal family. In the

early twentieth century, avant-garde artists, including Hannah Höch and John Heartfield, used collage and photomontage as often scathing commentary on social and political issues, while Pablo Picasso and Georges Braque changed the course of modern art when they began incorporating pieces of newspaper reportage on war and labor unrest, along with oilcloth, playing cards, restaurant menus, and other printed matter, into drawings and paintings. Since then, collaging techniques have been used by artists from Robert Rauschenberg to Barbara Kruger in challenging and provocative ways. Thomas Hirschhorn's work is built on an expanded notion of the collage, which moves fluidly between

two and three dimensions. And the trend toward collage has only expanded under the influence of computational media and the Internet.

In the Triennial, Elliott Hundley's work is the most lavish example of collage, its extravagant surfaces layered with his own photographs, found images, paint, pins, beads, and miscellaneous found objects. Hundley uses collage to create rapturous, exploded narratives that combine literary story lines and personal alliances. Wangechi Mutu's collages are visually stunning as well as overtly political, taking on issues of race, colonialism, and gender in complex works composed of pictures taken from an array of sources including

fashion, pornography, medical, and men's magazines. In contrast, Sohei Nishino takes all of the photographs he uses in his *Diorama Maps*. After making thousands of photographs while walking the streets of New York, Paris, Tokyo, Istanbul, and other major cities, Nishino prints the images, edits, and cuts up a few thousand of them. Then they are obsessively pieced together to create his own vast panoramas of the city, in which familiar landmarks look skewed and streets run at crazy, reconfigured angles. It is this ability to integrate layers of imagined plot lines, fantastical narratives, political commentary, and impossible places that makes collage so vital in an era characterized by fragmentation, volume, and speed.

CS

Community

The reconfiguration of social relations effected by the web, particularly revamped meanings of "community," is the subject of a number of works in the exhibition. Artists are exploring the network ideology of the web, what it means to be able to organize and align around specific affinities, and the possibilities for collaboration, connection, and multiple authorship across physical boundaries—as well as the limitations of these new avenues of expression.

A. K. Burns' *Touch Parade* is a five-channel video installation in which the artist reenacts fetish videos posted to YouTube. By turns humorous, seductive, and unnerving, the clips show the artist stomping on food, inflating a balloon until it pops, and other activities that are not immediately legible as erotic to the uninitiated. While the videos represent disembodied, anonymous online communities, Burns' strategy is to insert her own body, and by extension, that of the viewer, into the work, forcing a compellingly visceral, experiential relationship to the piece.

Nayland Blake is similarly committed to the notion of "art as an experience, not buttressing a theoretical argument," and his work also engages performance and queer community. In his recent installation *Free!Love!Tool!Box!* at the Yerba Buena Center for the Arts in San Francisco, Blake takes as his starting point a predigital example of community created through the circulation of photographs: Bill Eppridge's 1964 photo essay on the San Francisco leather bar The Tool Box appeared in *Life* magazine at a time when there was almost no media representation of gay life, much less the leather community. The photographs contributed to the growth of that community, by pointing to a physical space where people could gather. While the images read as an exposé or ethnographic study to outsiders, to those men seeking each other, they were a wayfinding device. In a counterpoint to this historical example of the circulation of photographs, Blake used his Tumblr page as a public sketchbook of images and inspiration—linked, as the platform stipulates, to other users with related interests—as he developed the project.

Many other Triennial artists present work that explores networks and collective experience in some way. Lucas Foglia documents self-reliant communities that have opted out of mainstream social and economic systems and abandoned many of the trappings of modern culture. These groups may look like back-to-the-land communes of another era, but they are interconnected online and fully embrace the ways the web facilitates knowledge-sharing. In Nica Ross' live collaborative performances, the artist remixes and projects video footage, often inviting audience members to contribute their own clips to her source material, which also includes YouTube videos, family footage, and vintage porn. These dynamic events create a temporary gathering space, dependent upon a live, participatory audience.

One of the Internet's claims is that it collapses geographical boundaries; people are able to access information and connect with one another in virtual space, creating the possibility of community unbound by geography. The radical potential of social media and the decentralized connectivity it enables was touted during the Arab Spring and Occupy protests. But Blake raises a note of ambivalence about the transformational possibilities of technology: "Occupy as a political moment was a reminder that physical space is important. Ultimately, online communities can be a huge catalyst, but there needs to be a physical component in order for them to have a real charge. Things flatten online, and people are starting to hunger for consequence."

KL

Mapping and Migration

A map is an index of the physical world, a way of ordering it and establishing a common understanding of its parameters. At a time when all manner of power structures are being called into question and even toppled, the map as an indicator of power and stability is a subject for inquiry. While maps can reflect a personal, idiosyncratic experience of geography, as in the collaged *Diorama Maps* of Sohei Nishino, they more often stand in for the omniscient view of power and regulation.

A geographer by training, Trevor Paglen uses photography to visualize activities that would otherwise be invisible: covert military and government systems, including placid skyscapes with barely visible drones hovering in the far distance. In the Triennial, these images are paired with a video of the drone's view of us, evincing two kinds of photographic vision, one automated and potentially lethal, the other deceptively distant and pastoral. His photograph *The Fence (Lake Kickapoo, Texas)* depicts the electromagnetic border around the United States, designed as a missile detection system. This border, which appears as a shimmering red field in *The Fence*, cannot be seen with the unaided eye. Paglen uses customized lenses to shift light into a visible spectrum in order to reveal the ever present but largely invisible militarization of our surroundings.

Mishka Henner's Google maps, which show the Dutch government's artfully pixelated top-secret zones, reference the regulation and censorship of virtual representations of physical territory. Aleksandra Domanović also questions the relationship between political nationhood and its online reflection in her stacked-paper monuments to the demise of the Yugoslavian domain name .yu in 2010, seven years after the country ceased to exist. What did this virtual ghost of a defunct country represent—was it a trace of a physical space, holding out hope that the country would reunite, or a meaningless bureaucratic oversight?

The regulation and control of geopolitical boundaries is continuously challenged and subverted by the undocumented flow of people across borders. Jim Goldberg's project *Open See*, a multiyear and continent-spanning exploration of refugees and migration, includes hundreds of portraits, many with notations handwritten on the prints by either the artist or the subject. "I was beaten by the Taliban" or "I had a narrow escape when the boat turned over" are fragments of individual stories too complex and varied to be lumped together or summarized in a unified statement on the subject of mass migration and refugee populations. His massive wall installation of portraits from the series *Proof* consists of contact or work prints pinned to the wall, signaling a work in process, still unfolding. With intentional blank areas left in its gridded hanging, it alludes to gaps in the archive, stories that have yet to be told.

These investigations of maps, borders, and geography certainly speak to the specific geopolitical contexts they describe, and to globalization and global economies more generally. But they are also part of a broader phenomenon of fascination with ordering systems, such as archives, in the face of the dematerialization, disorder, and anarchic excess of the web.

KL

Post-Photography

It is now just over twenty years since the first debates over the significance of digital imaging technologies first took place. Already in 1992 the subtitle of William J. Mitchell's book *The Reconfigured Eye* set the tone for the discussion: *Visual Truth in the Post-Photographic Era*. During the following decade, it was largely the question of the veracity of the new pixel-based images, compared to older forms of photography, that occupied such figures as Martha Rosler, Jonathan Crary, Fred Ritchin, and Geoffrey Batchen. By 2010, a critical consensus seemed to have been reached, reflected in this resigned admission of historian Alan Trachtenberg: "In the old photography, the camera is an instrument of memory; in the new photography, the camera itself serves as an electronic repository of memory from which a past, a simulacrum of any past, can be called up and programmatically shaped." Trachtenberg characterized the transition to the digital era as "a quiet cultural revolution of incalculable consequence."

Trevor Paglen, *Drone Vision*, 2010. Courtesy the artist, Altman Siegel, San Francisco, Metro Pictures, New York, and Galerie Thomas Zander, Cologne.

Trevor Paglen, *Untitled (Reaper Drone)*, 2010. Courtesy the artist, Altman Siegel, San Francisco, Metro Pictures, New York, and Galerie Thomas Zander, Cologne.

Not only critics and theorists but leading photographic practitioners echoed this message that an irrevocable shift had occurred. Interviewed in the *New York Times* Lens blog in the summer of 2010, a year before his death on assignment in Libya, Magnum photographer Tim Hetherington unapologetically proclaimed, "If you are interested in mass communication, then you have to stop thinking of yourself as a photographer. We live in a post-photographic world."

For many artists included in this Triennial, such as Oliver Laric, Andrea Longacre-White, and Aleksandra Domanović, the digital revolution is something that occurred in their childhood, and dealing with its consequences has occupied most of their lives. They may employ digital or traditional chemical photographic techniques in their current work, but they all understand that their efforts are situated within the new regime of the digitized, networked image.

CP

Self-Publishing

The photo book, as any enthusiast will tell you, is a medium distinct from photography, a sibling born in the same era. Presenting photographs in codices (along with text, in many cases) links the form and content in a way that single prints or exhibitions of photo works do not, and the intimate communion between book and reader is an exchange not offered by any other experience regarding photography. A photo book is distributed, it travels, it builds lifelong relationships, it informs and influences other practitioners. It is central to the history of photography. The early 2000s saw a marked rise in interest in the form, with publications by noted collectors such as Andrew Roth's *Book of 101 Books* (2001), and Martin Parr and Gerry Badger's two-volume *The Photobook: A History* (2004).

In the surrounding years, we have seen the technological advancement of desktop publishing, scanners, digital photography, and color digital offset printing, all against the backdrop of Web 2.0. These developments constitute "a perfect storm of technological innovation," as curator Barbara Tannenbaum puts it, in the publication that accompanied *DIY: Photographers & Books* at the Cleveland Museum of Art (2012), which has empowered photographers to create and distribute books without the coveted support of a commercial publisher. Whether creating small editions of their own, through independent publisher/printers, or creating open editions with the growing array of print-on-demand (POD) platforms, photographers have taken the means of production into their own hands in unprecedented numbers.

On one hand, the self-publishing phenomenon can be seen as a consequence of the anxieties of the information age, an era in which all data, including images, is created and transmitted with increasing speed. The digital seems to produce in us a reactive longing for the tangible and handmade, evident in all aspects of today's culture, from the upsurge of crafty, anachronistic practices like letterpress to the current craze surrounding artisanal food.

We perceive in the handmade an authenticity that we miss in the digital, even as we use the digital to

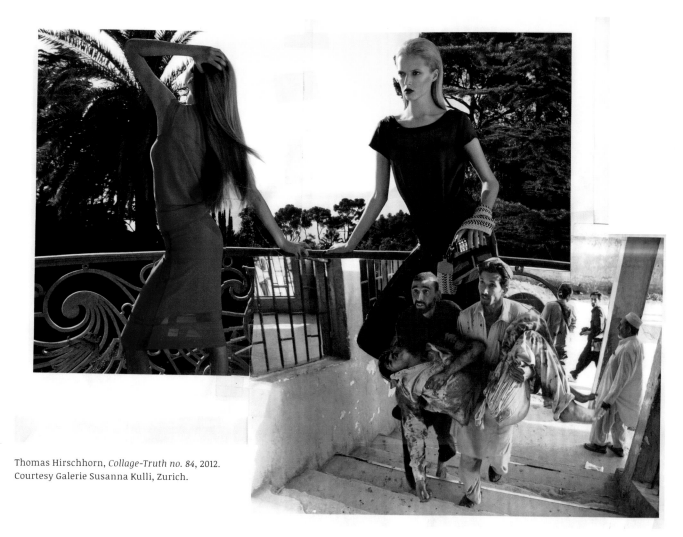

Thomas Hirschhorn, *Collage-Truth no. 84*, 2012.
Courtesy Galerie Susanna Kulli, Zurich.

document and distribute images of the "authentic." One example of this phenomenon can be observed in the aesthetics of the Occupy movement, where scraps of salvaged cardboard, on which messages are scrawled with a Sharpie, have become emblematic. The humble materiality of these testimonies somehow conveys the urgent dynamic of live protest for which they are created. But their secondary and more far-reaching purpose is to be photographed and shared on the web. While digitally designed slogans could just have easily taken off, a wildly popular meme, which consists of ordinary citizens holding a handwritten account of their personal struggles under the current economic system, with the tagline: "I am the 99%," was

among the most disseminated Occupy imagery. (This meme is archived on the Tumblr wearethe99percent.tumblr.com/archive.)

This perceived authenticity of the handmade is endemic in the photography community, where we face the virtual extinction of darkroom practice, that physical, chemical process on which generations of practitioners wax romantic. Most photography is now produced, processed, and distributed in digital space.

The new self-published photo book is often not technically "handmade," but the ability to publish their own book gives photographers—whose work lives now include at least equal

time in front of computer screens as with cameras—a relatively affordable, tangible object to circulate. Triennial artist Sam Falls has a particular commitment to the practice. "I got really tired of the Internet viewing arena and blogs, and I think books are a nice way to share my work with people . . . without burdening them with galleries and high prices," he explained in an interview with fellow artist Lucas Blalock. The series *Dutch Landscapes*, by Mishka Henner, exhibited in the Triennial, was published as a book on the POD platform Blurb, as are several other projects by Henner.

Henner is a member of Artist Books Cooperative, a self-selecting network of photographers who make POD

books and promote one another's work. Such self-organizing groups comprise a tiny fraction of the networked activity that is occurring around the self-published photography book. The phenomenon has enlivened and enriched a large portion of the photography community, and this community exists in both digital and physical space. Exchange about photo books now happens in Facebook groups and innumerable blogs, in addition to workshops, contests, conferences, and showcases. And photographers turn to these networks to fund their projects as well; modes of crowd-sourcing like Kickstarter have become the most common way to pay for a print run.

The lack of mediation in the production of self-published photo books lends itself to this kind of community of insider-y connoisseurship. While a traditional publisher positions a book as a product for marketing, by explaining and contextualizing for us, few of the small press and self-published books displayed in ICP's Triennial announce what they are. There is no explanatory flap copy, no quoted recommendation from known artists, generally no artist's statement or commissioned essay. The passionate fans of these DIY books discover their favorites by dint of their unique tastes, and through recommendations from the communities that have sprung up around photo books, who gather, blog, and otherwise commune on their mutual enthusiasms, furthering a critical discourse. The discourse, in turn, spurs more production. This loop, from the digital to the physical and back again, feels emblematic of our present condition in regard to photography, and further, is mirrored in every other aspect of our networked lives today.

JL

The New Aesthetic

On May 6, 2011, James Bridle, a young London-based digital publisher, launched a Tumblr page that he called "The New Aesthetic." It was a project born of his frustration, he said, at the lack of a common visual and conceptual language with which to assess the growing presence of digital technology and networked systems in every corner of contemporary life. Relentlessly posting images and media items culled from an extraordinary range of sources, Bridle insisted that his "New Aesthetic" blog was "not criticism but exploration; not a plea for change, rather a series of reference points to the change that is occurring." By the time that he stopped adding new posts precisely one year later, "The New Aesthetic" had become one of the most widely and contentiously debated cultural signposts of its moment.

Bridle's blog proved so influential because of his success in demonstrating the underlying connection between a host of seemingly scattered cultural phenomena. Almost all of the posts highlight the increasing overlay of a digital, networked reality onto the human experience of the world. The New Aesthetic encompasses the rising use of glitch photos, QR-code images, and data-moshing visuals in graphic design; the exploration of the aesthetics of jpeg compression by artists such as Thomas Ruff; the growing presence of face-recognition technologies in everyday life; the nine-eyed robot cameras employed by Google Streetview vehicles; the growing ability to access high-resolution, real-time satellite views from mobile phones; the evolution of 3-D, moving-image infographics; the sophisticated HDR (high dynamic range) photographic software now installed in iPhones; the introduction of telepresence robots; and the seeming ubiquity in the skies of military, commercial, and personal drones.

Perhaps because Bridle cheerfully admitted his lack of detailed knowledge about contemporary art, it is all the more interesting to see which artists found their way into the "New Aesthetic" Tumblr: Ruff, Trevor Paglen, Gerhard Richter, John Stezaker, Doug Rickard, Cory Arcangel, and Mishka Henner, among others, almost all of them male. In the end, however, "The New Aesthetic" has proved far less valuable as a guide to emerging art trends than for identifying the new types of imagery that are beginning to coalesce into a twenty-first-century digital vernacular.

CP

Roy Arden

Roy Arden first achieved recognition in the 1980s as part of a group of Vancouver-based artists that included Jeff Wall, Ian Wallace, Stan Douglas, and Rodney Graham. Like those artists, his earliest works show a strong attraction to the possibilities offered by photography as a modernist medium. Arden is also a consistently sharp-eyed and insightful critical writer whose essays reveal the unusual breadth of his intellectual and artistic interests.

His earliest works, such as the series *Rupture* and *Abjection* (both 1985), examine photography's role in shaping personal and historical memory, pairing photographs of traumatic public events taken from Vancouver's civic archives with monochromatic images of the sky. His 1990s series *Landscape of the Economy* reveals a new interest in the documentary style pioneered by Eugène Atget and Walker Evans. These large color prints are a dour meditation on the transformation of Vancouver by economic forces that threaten to uproot the city's older communities. *Terminal City* (1999), a suite of seventeen black-and-white works that serves as a kind of coda to *Landscape of the Economy*, takes the viewer on a gloomy tour of the marginal urban zones that function as the last stop for those whom Arden styles "refugees from late capitalism": disaffected teenagers, drug addicts, prostitutes, and the homeless. Throughout, he offers considerable insight into the process by which high art has systematically annexed low subject matter.

In the past decade, Arden has dramatically expanded the range of his artistic practice, which now includes painting, sculpture, collage, and video. An inveterate collector of images since childhood, he was quick to see that the Internet would trigger an explosive growth of the visual universe. His regularly updated Tumblr blog UNDERTHESUN brings together an apparent cacophony of images—reproductions of artworks from all periods and styles, news photographs, snapshots, album covers, commercial designs—that have caught his eye and set off his speculative imagination.

Arden's 96-minute Quicktime video *The World as Will and Representation* (2007), a fast-paced stream of roughly 10,000 individual images, is one of the key works to have grown out of contemporary artists' response to the new possibilities of image collecting. Keenly aware of earlier figures such as Hans-Peter Feldmann, who in the 1970s was one of the first artists to make the move to pure appropriation of existing images, Arden set out with specific ground rules in assembling his own visual archive for this work. The images that he chose had to be photographic, nonartistic, vernacular, and clearly show something that exists in the world. The sequence of images follows the ordering of Arden's archive, which employs subject-oriented folders to which he has assigned titles. This facade of reasoned objectivity masks what he admits is a pursuit governed more by impulse and curiosity than by logic. Arden writes: "If my archive is about the necessity of collecting and ordering images of the world, it is also about the sheer folly of such an enterprise."

Christopher Phillips

Born in
Vancouver, British Columbia, 1957

Lives and works in
Vancouver

16

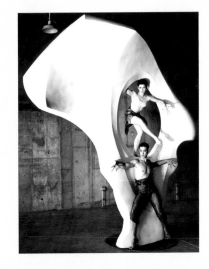

Putty	Warm Tan	Buckskin	Warm White
Sage	Olive Green	Mist Green	White
Light Gray	Med. Gray	Dark Gray	Black

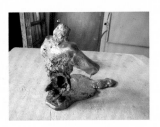

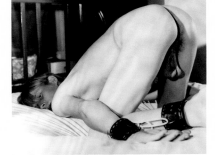

Bachelor of Fine Arts, 2007

17

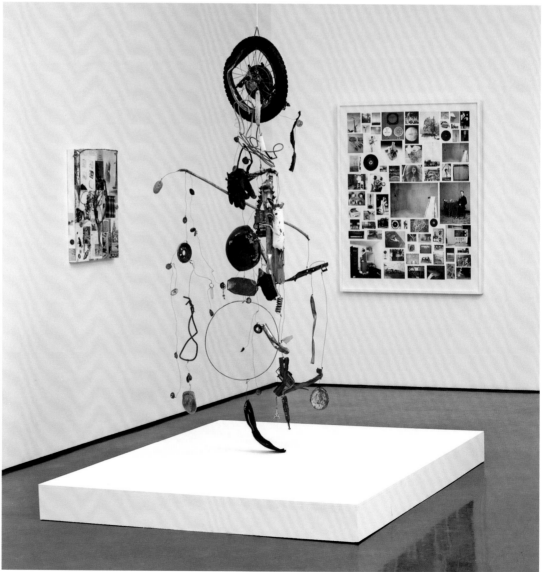

ABOVE *The World as Will and Representation— Archive 2007*, 2007

RIGHT Installation, *Vox*, Monte Clark Gallery, Vancouver, November 2011– January 2012

ABOVE *Boy*, 2012

RIGHT *Vision*, 2012

Down There, 2007

The Terrible One, 2007

Huma Bhabha

Modernity, ruin, landscape, myth, and memory all factor into Huma Bhabha's remarkable sculpture and photographic drawings. Her sculptures have a monumental quality but are often made of modest, cast-off materials—Styrofoam, salvaged wood, chicken wire, clay, cork, an animal skull, rubber, plastic—that seem to cohere more by force of will than by ordinary bonding techniques. Some of her newer sculpture is cast in bronze, but other pieces are made with pointedly fragile material, such as unfired clay, and exist only to be photographed.

Many of her photographs, mostly taken in and around her hometown of Karachi, in black-and-white and color, are created to be the basis for unique works that she calls photographic drawings. They show arid landscapes that appear ruined, scraped clean of life, rutted and dry, or dotted with the remains of abandoned or half-finished buildings that are slowly disintegrating, as if modernity is no match for either nature or the past. After printing the photographs, Bhabha draws on them in ink, sketching huge feet, giant faces, or monumental figures that might belong to a tribe of long-departed colossi whose spirits haunt the land. Her lines can be faint, almost spectral, meandering or direct, aggressively thick and insistent. Some images are collaged or washed with swathes of acrid color that create incandescent new atmospheres and sketch in imaginary spaces. Her wide range of passions and references include African masks, ancient Egyptian sculpture, science fiction and horror movies, Cubism, Expressionism, Minimalism, and pop culture. These influences represent at once the past, present, and future, as if from her own time she has caught a glimpse of the next millennium and is filling it in over documentary images of the recent past.

Bhabha's work can be both brutal and romantic, and she has written that the destruction of war and environmental damage influence her as much as the ruins of the ancient world. "My goal is that each work should be intense in its presence, and aggressively attract the viewer. I'm very interested in beauty, but I like it best when it's unexpected," she has said. "Karachi, for example, is not a beautiful city but occasionally you will notice something as you are driving around—like an impromptu construction shack made out of found planks of wood—that can take your breath away. Sometimes beauty is a matter of taking the time to appreciate something in a different way, or noticing connections where you hadn't seen them before."

Carol Squiers

Born in
Karachi, Pakistan, 1962

Lives and works in
Poughkeepsie, New York

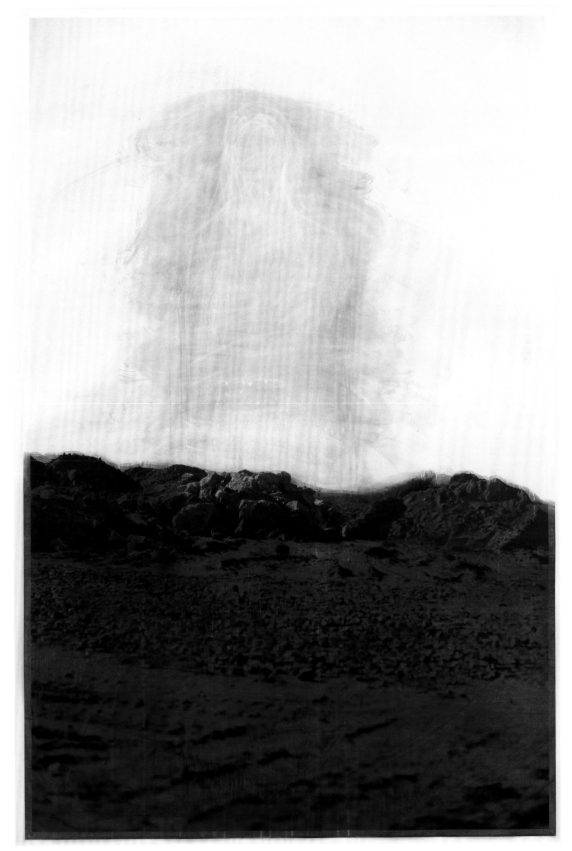

Untitled, 2010

Untitled, 2008

Bagram, 2010

OPPOSITE TOP *Untitled*, 2007

OPPOSITE BOTTOM *Untitled*, 2010

RIGHT *Untitled*, 2010

BELOW *Untitled*, 2007

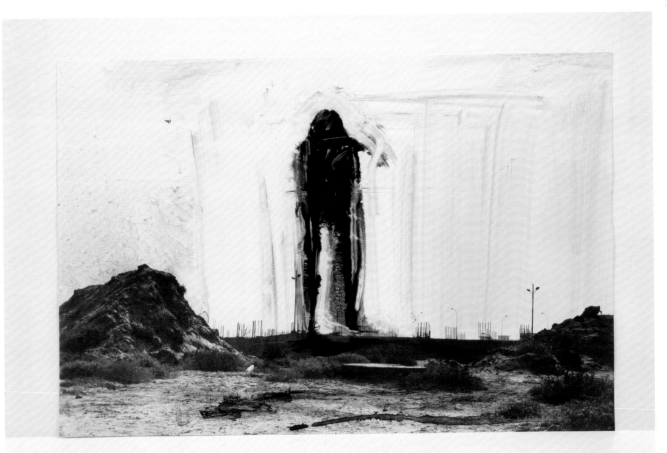

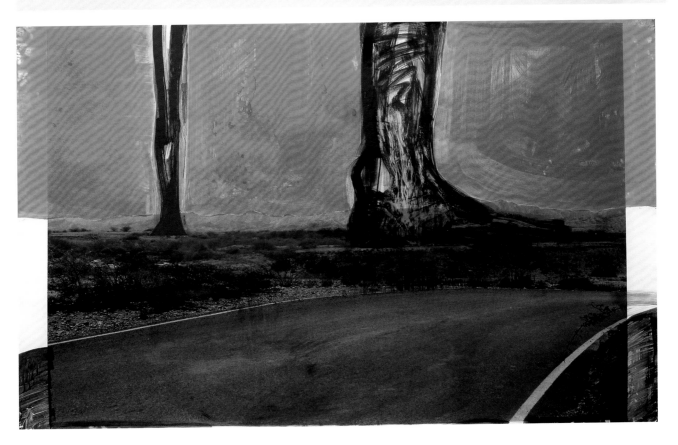

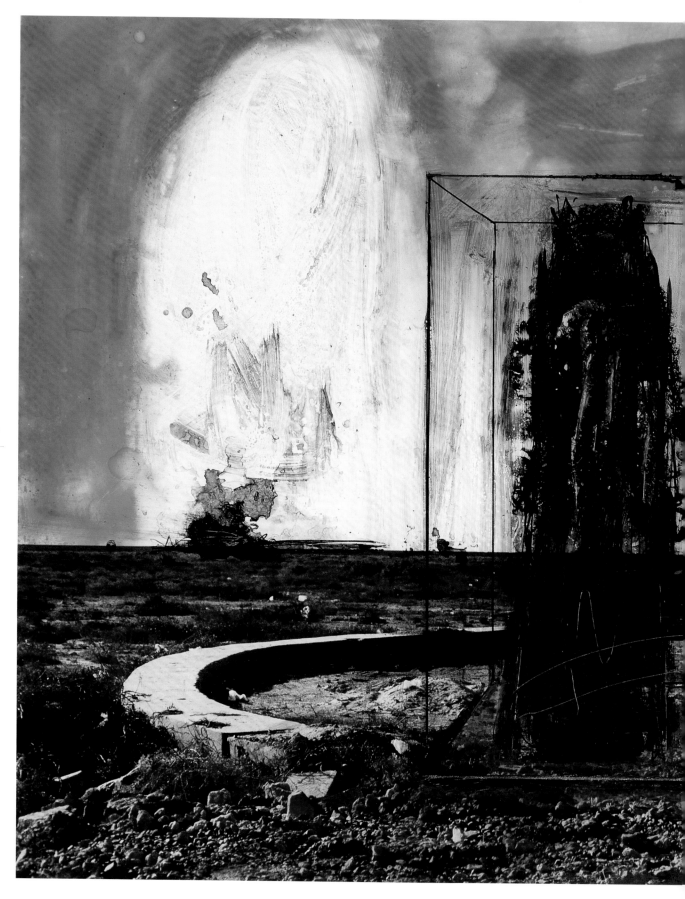

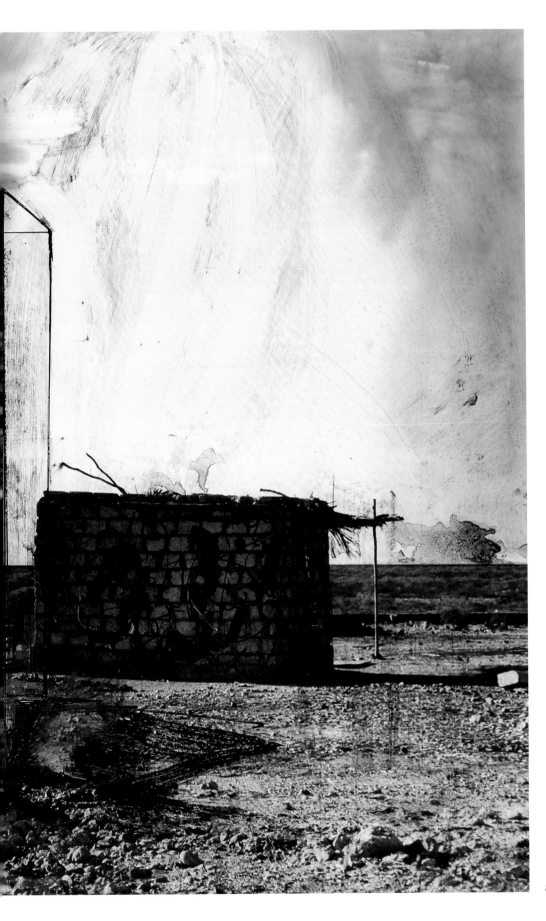

Untitled, 2008

Nayland Blake

After attending CalArts in 1984, Nayland Blake did not remain in Los Angeles or return to his hometown of New York—cities renowned as art world centers—but instead relocated to San Francisco, America's gay capital, which was in the midst of the HIV/AIDS crisis, and which also had a small but freewheeling and innovative art scene. There, Blake rapidly emerged as a distinctive and charismatic artist (and curator), using things campy and refined, fetishistic and exquisite, with both humor and keen intelligence to explore complex issues of sexual and racial identity (his father is black and his mother white). Rooted in personal experience, Blake's art is often raw and emotive. For the performance/video *Starting Over* (2000), he donned a 146-pound (the exact weight of his partner at the time) white bunny suit and danced about with taps on his shoes. Already an ample, bearded, tattooed man (a "bear" in gay parlance), Blake's heavy bunny costume made him even heftier and painfully encumbered. His poignant travesty of tap dancing, with nineteenth-century African-American origins, conjoined exuberance and exhaustion, joy and unease, while the bunny suit abounded with references: to the wily trickster Br'er Rabbit, derived from West African folklore; Bugs Bunny, who often appeared in drag; Playboy bunnies; and rabbits per se, notorious for their sexual proclivity.

Blake's idiosyncratic art spans sculpture, performance, painting, drawing, video, assemblage, bricolage, photography. Sculptures made from found objects such as clothes, masks, dolls, glass beads, plastic flowers, and fabrics are both alluring and unnerving. *Feeder 2* (1998) is a gingerbread house writ large, that one can enter, made of gingerbread squares fitted around a steel armature. In the performance/video *Gorge* (1998), a shirtless Blake quietly sits on a chair, facing the camera. A shirtless black man feeds him a gut-wrenching assortment of foodstuffs: pizza, a hero sandwich, doughnuts, chocolate, watermelon, milk, and Perrier water, while the jaunty song "Bunny Hop" plays as a loop. Pleasure and pain, nurture and domination, freedom and compulsion, eroticism and alienation, even childhood and adulthood, are all entwined.

Blake's contribution to the ICP Triennial arises from his recent exhibition *Free!Love!Tool!Box!* at Yerba Buena Center for the Arts in San Francisco, an acclaimed homecoming for this artist who has lived in New York since 1996. The sprawling, in-flux exhibition featured spontaneous sculptures made from found materials, including clothes donated by visitors; a DJ booth where visitors could spin records from Blake's vast collection; and a recreation of Chuck Arnett's 1962 mural of gay men once displayed at The Tool Box, the San Francisco leather bar Bill Eppridge famously photographed for *Life* in 1964, providing many astonished readers with their first glimpse of leather subculture. In the months leading up to the exhibition, Blake authored a Tumblr account filled with evocative images he had collected and received. For the Triennial, he delves into ICP's collection, which includes those Eppridge photographs, with a mixed-media installation that invites audience participation and doubles as a cathartic meeting ground.

Gregory Volk

>> Born in
New York, 1960

Lives and works in
New York

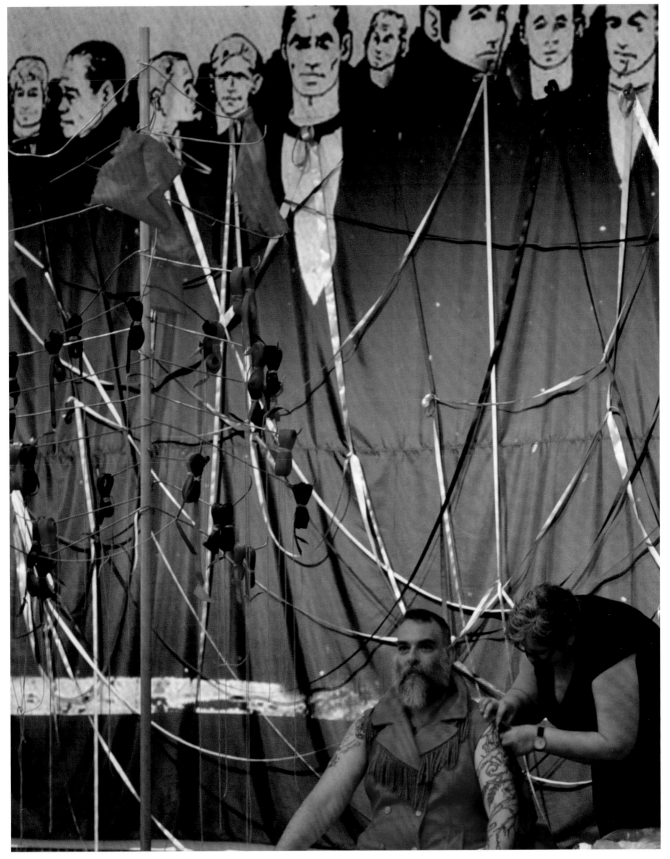

Installation, *FREE!LOVE!TOOL!BOX!*, Yerba Buena Center for the Arts, San Francisco, October 2012–January 2013

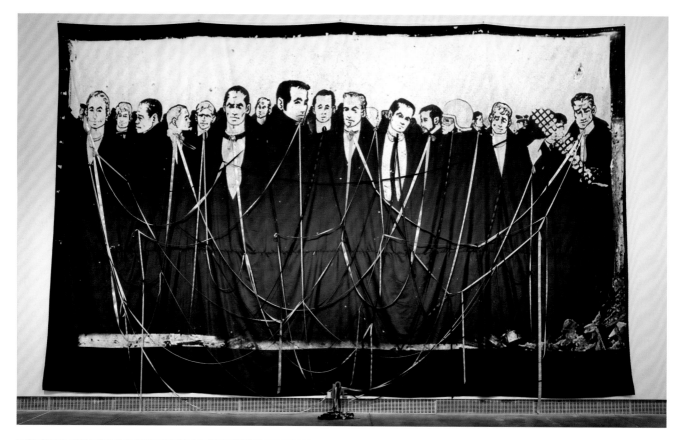

Installation, *FREE!LOVE!TOOL!BOX!*, Yerba Buena Center for the Arts, San Francisco, October 2012–January 2013

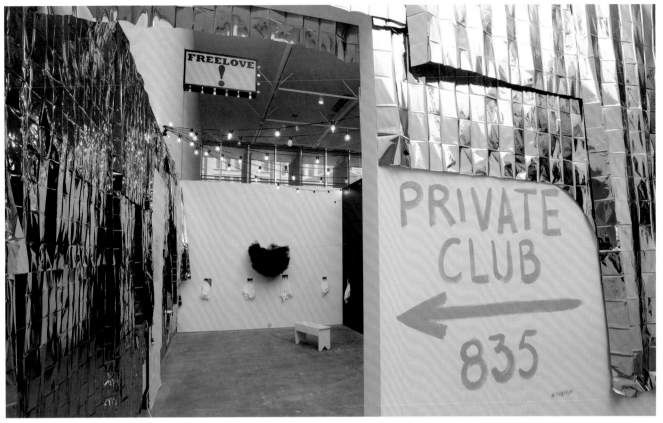

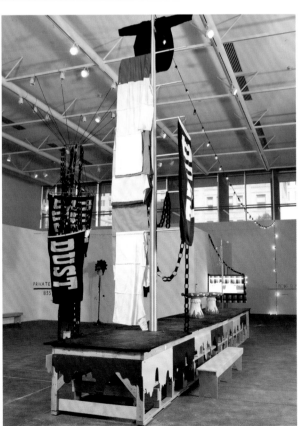

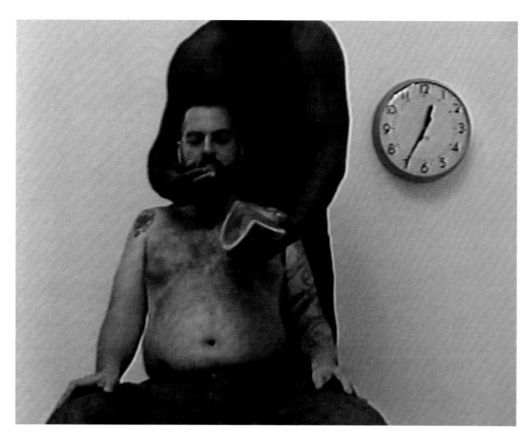

Gorge, 1998

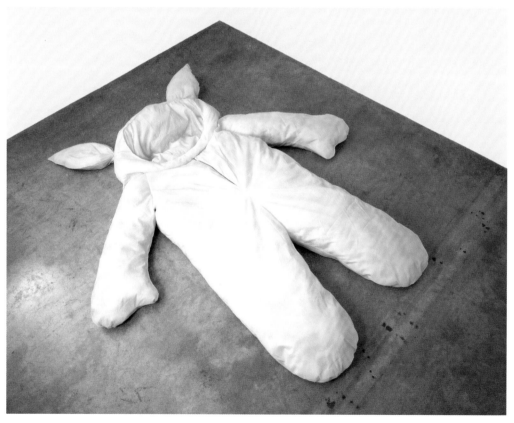

The Big One, 2003

Feeder 2, 1998

A.K. Burns

A. K. Burns is a multidisciplinary artist whose work in film, sculpture, video, and other media is rooted in feminist and queer politics and deals with themes of power relations, sex, communal practice, and the body. Burns is a founding member of the advocacy group W.A.G.E. (Working Artists and the Greater Economy), and co-editor of *RANDY*, an annual transfeminist and "vag-centric" arts magazine.

Burns' best-known work is *Community Action Center* (2010), a feature-length queer porn film created in collaboration with A. L. Steiner. Evoking the improvisational body-based performance of early feminist work, the film presents a series of exuberant and explicitly erotic encounters between a community of friends, lovers, and fellow artists. Participants engage in orgiastic scenes with food, evoke pagan ritual, and celebrate a panoply of unconventional gender presentations. In an especially vivid scene, one partner sews a delicate pattern of feathers onto the other's backside with a needle and thread, and the concentrated intensity of the exchange transcends any conception of coolly cerebral artmaking. The work demands a different kind of viewing, one that is deeply visceral and experiential.

In addition to this critically acclaimed film, Burns works in a range of other media, for both solo projects and collaborations with other artists. Her show *Pregnant patron penny pot* (2012) included minimalist sculptures covered in faux-granite Formica, paired with photocollages printed on vinyl-coated canvas, draped from pennies slotted into a groove in the wall. With images drawn from the New York Public Library archive, the collages incorporate photographs that summon a range of associations with power, labor, consumerism, and gender: one image combines strollers at an Occupy event for parents, a fertility goddess, and the "Charging Bull" symbol of Wall Street. Draping in upon themselves to obscure most of the image, the collages invite viewers to open up the unmistakably labial folds in order to see the full work.

Touch Parade (2011) elicits a similarly physical response. In this five-channel video installation, Burns re-enacts fetish videos found on YouTube. The artist alternately crushes food underfoot, inflates a balloon until it pops, and other activities that are not immediately legible as erotic to the uninitiated. Because the source videos are so ambiguous, they have also managed to elude the site's censors, calling into question what constitutes illicit and licit behavior online, and how that gets policed. (To this end, Burns was only interested in drawing source material from the general-use YouTube, not the explicitly porno-graphic Xtube.) While the videos represent disembodied, anonymous online communities, Burns' strategy is to insert her own body, and by extension, that of the viewer, into the work. Alternately funny, unnerving, and absorbing, depending on the viewer, the work points to the deeply personal and ineffable language of desire.

Kristen Lubben

》 Born in
Capitola, California, 1975

Lives and works in
Brooklyn, New York

A. K. Burns and A. L. Steiner, *Community Action Center*, 2010

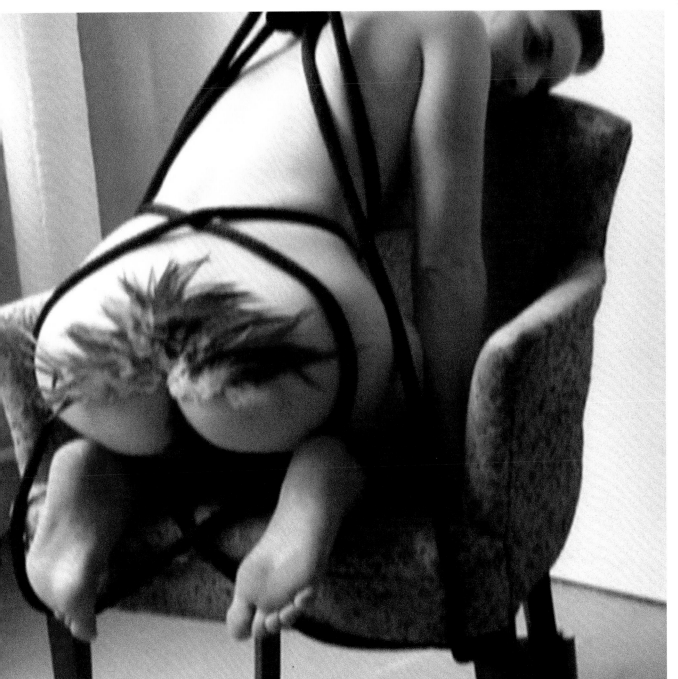

A. K. Burns and A. L. Steiner, *Community Action Center*, 2010

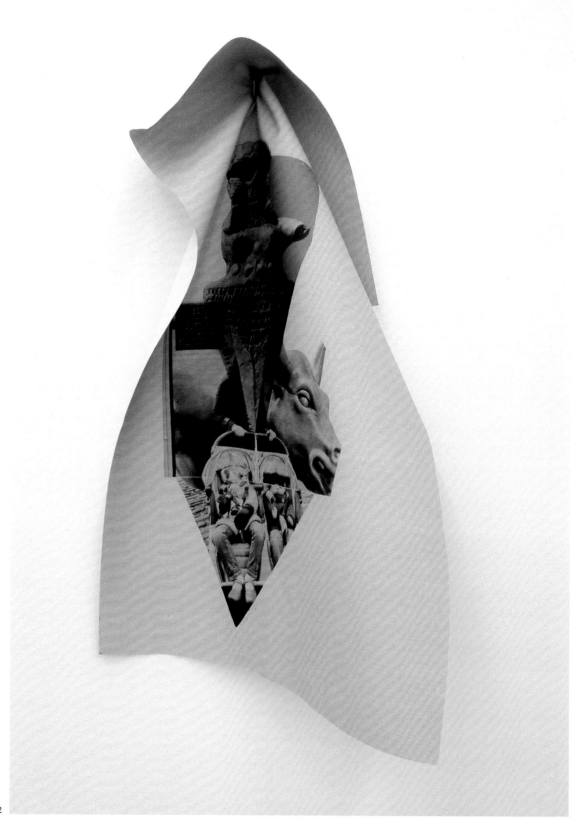

Fertility Bull, 2012

In Labor, 2012

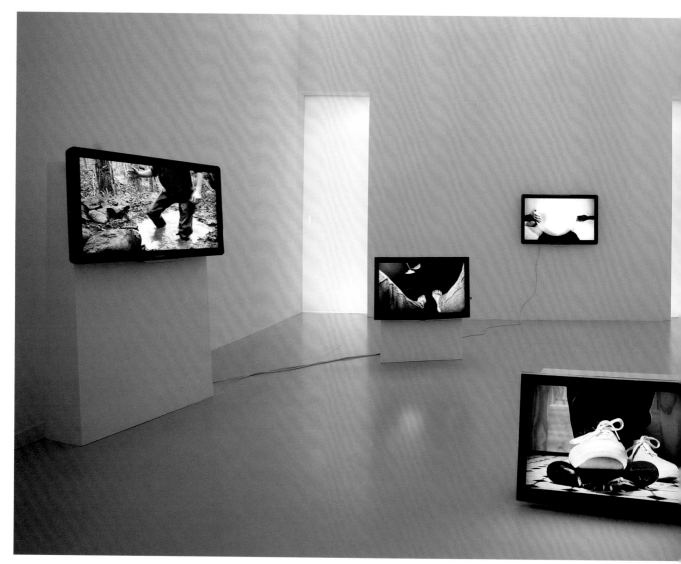

Installation, *Touch Parade*, TAG The Hague, 2012

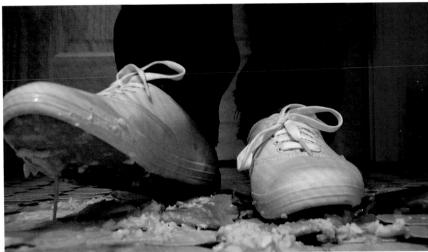

TOP *Touch Parade (crush),* 2011

MIDDLE *Touch Parade (squeeze-2-pop),* 2011

BOTTOM *Touch Parade (wading),* 2011

Aleksandra Domanović

The year 1991 is important in Aleksandra Domanović's work. It marks the official beginning of the civil wars and ethnic cleansing that destroyed Yugoslavia as a unified republic. But it was also the year the country got its own international, country-specific domain—.yu—on the brand new World Wide Web. The destruction of real-world bombs and bullets proved to have a more substantial impact than the digital imaginary of cyberspace. Yugoslavia ceased to exist as a country in 2003, although its domain designation lasted another seven years. When the .yu was deactivated, it was a final, symbolic marker that Yugoslavia was gone.

Domanović works across a variety of media and genres, using photography, Internet and video sampling, digital modeling, and animation in works that address the cultural consequences of Yugoslavia's demise. For one series of photographs, she began with images of Yugoslavia's longtime president Tito, whose pictures were displayed in classrooms throughout the country when Domanović was growing up. Working with a 3-D computer modeler in the Ukraine, she asked him to make a bust from the photos and then to feminize Tito's features. His image was then again altered, using a computer-generated brass finish in *Portrait (mesing)* (2012) and a marble texture in *Portrait (bump map)* (2011).

In place of discredited and divisive political heroes, a movement emerged in the former Yugoslav republics to celebrate pop culture figures like Johnny Depp and Rocky Balboa with public monuments. But when a bronze statue of martial arts deity Bruce Lee was unveiled in Bosnia and Herzegovina in 2005, it was quickly vandalized and removed from view. Lee's statue stars in Domanović's *Turbo Sculpture* (2010–12) video, a look at the absurd mashups of postwar culture.

Unlike artists who promiscuously troll the web for ready-to-use pictures, Domanović conducts a very deliberate, historically informed search of its picture sources. In her stacked-paper "printable monuments to the abolished .yu domain" such as *Untitled (30.III.2010)* (2010), she uses images of soccer hooliganism in Serbia to represent both nationalistic violence and the continuing violence that occurs in the name of sport. It was a soccer match that is considered the opening salvo in the war that consumed Yugoslavia. On May 13, 1990, the soccer teams Dinamo Zagreb (Croatian) and Red Star Belgrade (Serbian) were scheduled to play in Zagreb. Each side's violent fans faced off in the stadium. Both groups were comprised of people who would be central to the bitter civil wars that started the following year, among them Željko Ražnatović, known as Arkan, the Serbian criminal and Red Star leader who organized a vicious paramilitary group. In the images, Domanović digitally emphasizes the billowing smoke and the destructive threat of the burning flares thrown on soccer fields in a neverending battle of political grievance and homicidal anger. Then she writes a computer program that extends the photographs to the margins of standard letter-sided paper when they are printed and formed into 9,000-sheet stacks. Although the war is over and Yugoslavia is no more, Domanović tracks the continuing cultural and political dislocations in the vestigial republics in works that are by turns comic, painful, and poignant.

Carol Squiers

>> Born in
Novi Sad, Yugoslavia, 1981

Lives and works in
Berlin

Untitled (mash-up), 2012

ABOVE, RIGHT, AND OPPOSITE Installation, *Untitled (30.III.2010)*, 2010, Kunsthalle Basel, April–May 2012

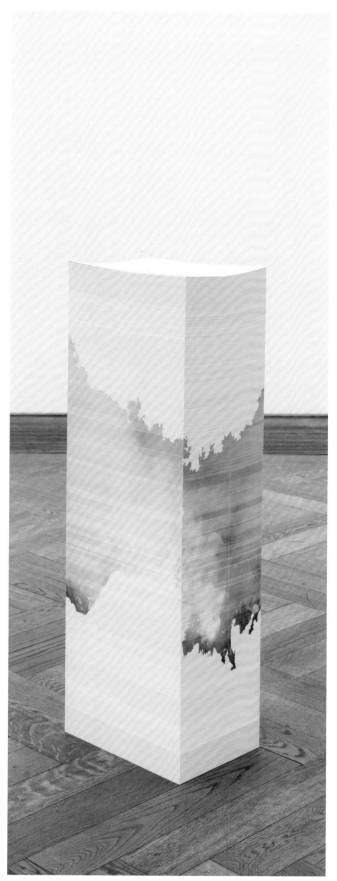

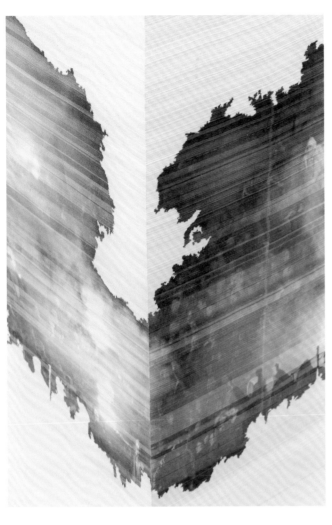
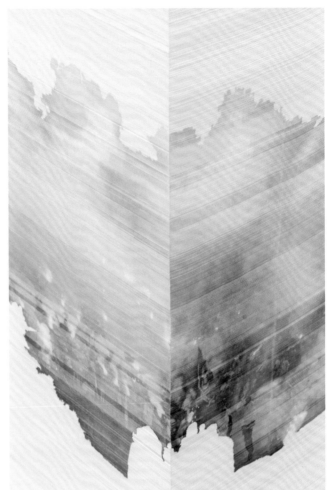

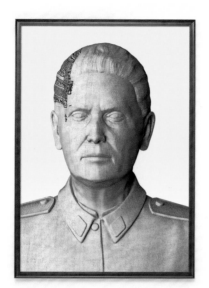

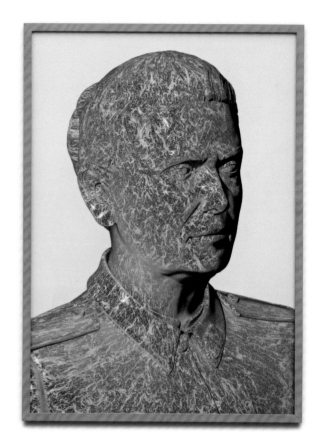

CLOCKWISE FROM TOP LEFT

Portrait (kilim), 2012

Portrait (bump map), 2011

Portrait (office), 2012

Turbo Sculpture, 2010–12

Nir Evron

Nir Evron's film and video works, which frequently explore the labyrinths of historical memory, are notable for their formal self-consciousness and their interrogation of the ethics and politics of vision. The video *In Virgin Land* (2006), for example, consists of a series of ten-second glimpses of barren Israeli landscapes captured in black and white by a static camera. Over the images, a narrator reads a selection of short texts, ranging in date from the twelfth to the twentieth century, about travelers' experiences of the geography of the Holy Land. All of them reflect a powerful, consistent desire to imagine the Holy Land as uninhabited "virgin" terrain available for settlement. This vision of a "land without people," Evron's work suggests, has proved willfully, and tragically, blind to the presence of the region's Palestinian inhabitants.

Oriental Arch (2009) is a slow, deadpan tour of the interior spaces of Jerusalem's Seven Arches Hotel, built in a regional modernist style in 1964 by the Jordanian royal family (in that year, the hotel was the site of the first meeting of the Palestine Liberation Organization). Since Israel's victory in the Six-Day War of 1967 and its annexation of East Jerusalem, the Seven Arches has been maintained by the Israeli government as a functioning if semi-deserted hotel. As Evron presents it, the Seven Arches is a ghostly relic of an unsustainable modernizing moment.

For the ICP Triennial, Evron presents *A Free Moment* (2011), a four-minute black-and-white work filmed on 35mm stock and transferred to HD video. Shot on a commanding hilltop in northeast Jerusalem, it unfolds within the open concrete skeleton of the summer palace begun in the mid-1960s by King Hussein of Jordan. This three-story modernist residence, located on a site that offers a panoramic vista of Jerusalem's old city and the suburbs of Ramallah, was left unfinished when Israeli forces captured East Jerusalem in the war of 1967. It was from the Israeli government that Evron obtained permission to film within the abandoned structure.

Employing a robotic camera installed on a dolly track that he laid out on the second floor of the palace, Evron made a film that consists of a single complex, pre-programmed shot. Opening with a breathtaking view looking down on the city of Jerusalem, *A Free Moment* moves quickly into unexpected visual territory, as the camera ceaselessly tilts and pans in a 360-degree circle, slowly traveling from one end of the dolly track to the other. In the process, close-ups of the building's interior architecture alternate with glimpses of the surrounding cityscape—now seen upside-down. With this kind of purposeful disorientation, *A Free Moment* takes up the legacy of "structural" filmmakers of the 1960s such as Michael Snow (particularly his avant-garde classic *La Region Centrale*). Evron's experimental exercise, however, is firmly anchored in the present moment, especially in its emphasis on the need to see and think in a new way about a very specific contested terrain.

Christopher Phillips

Born in
Herzeliya, Israel, 1974

Lives and works in
Tel Aviv

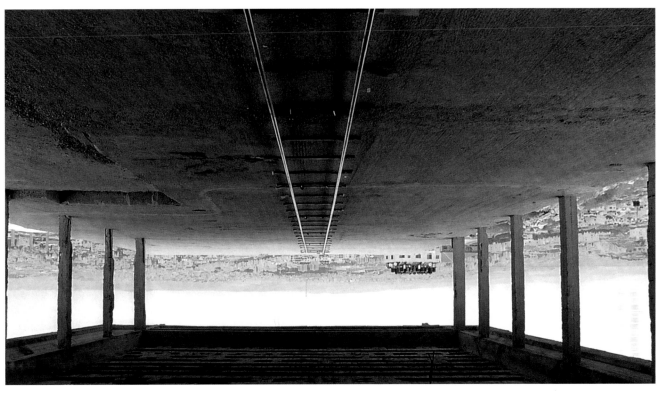

A Free Moment, 2011

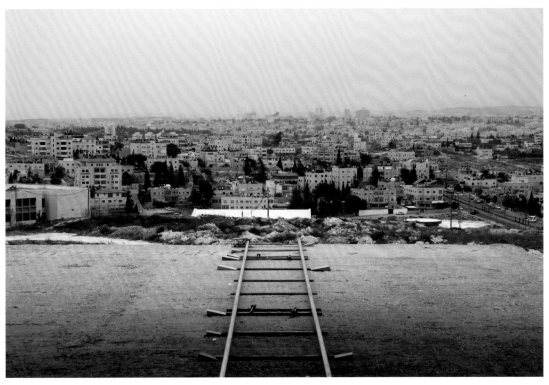

Production still, *A Free Moment*, 2011

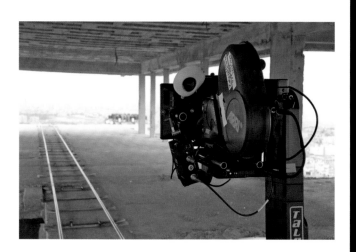

Production stills, *A Free Moment*, 2011

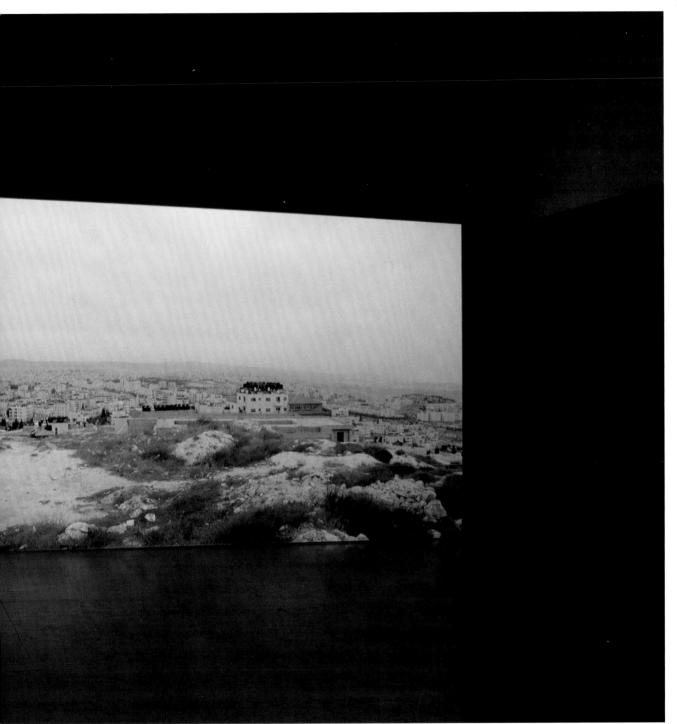

Installation, *A Free Moment*, 2011

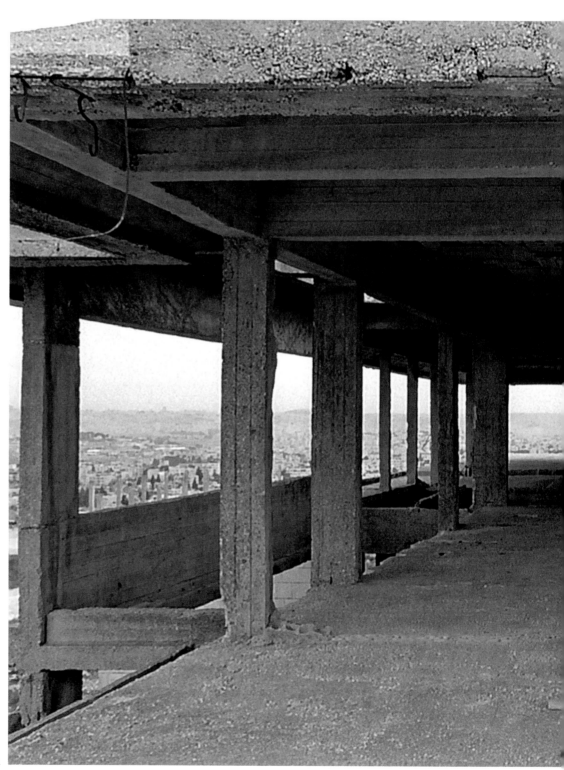

A Free Moment, 2011

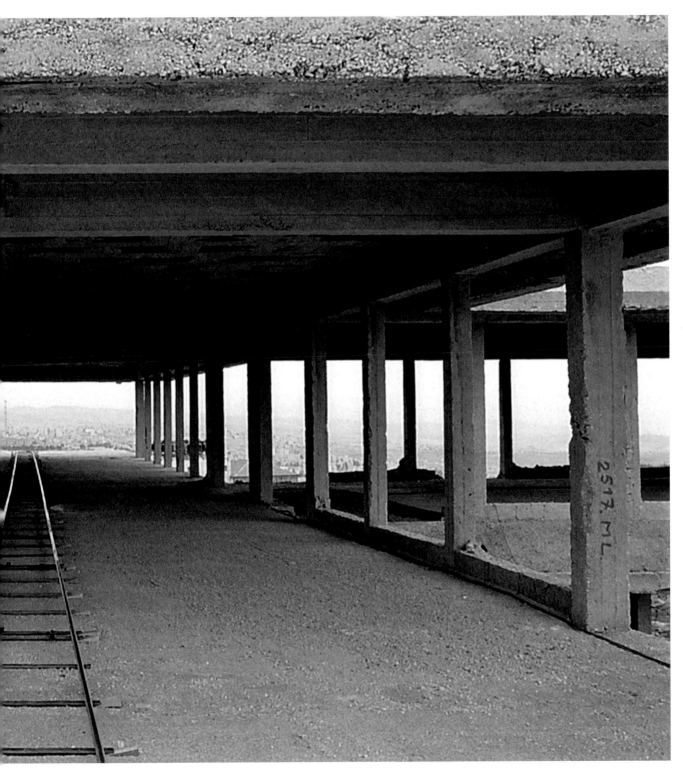

Sam Falls

Mixing photography, painting, drawing, computer rendering, video, printmaking, and sculpture, Sam Falls' work is steeped in a freewheeling sensibility that is one of the hallmarks of his generation of artists. But although he regularly employs a host of different mediums, the notion of "the photographic" remains the conceptual motor for much of what he does, guiding his thinking about the ways that the variables of light, space, and time can be employed to shape an image. Falls produces art that is at once wildly improvisational and relentlessly idea-driven: he worries less about the stylistic coherence of his output than the consistency of its creative logic. "The notion of an artist working in one style doesn't make any sense," he says flatly.

The works included in the ICP Triennial are selections from three recent groups. In mid-2011, Falls traveled to Joshua Tree, in California's Mojave Desert. Drawn to the squat, abandoned sheds that he found scattered throughout the area, he decided to hang lengths of intensely colored, hand-dyed fabric in their windows and doorways. After photographing the buildings, he worked on the images in the computer, digitally inserting blocky geometric shapes in colors matching those of the pictured fabrics. After making digital prints, he used a hand-roller to embellish the sky areas with similarly colored swaths of enamel paint.

In 2012, he produced a group of pulsatingly psychedelic "painted photograms" that seamlessly combine airbrushed acrylic paint and abstract photographic passages. In a third group, also from 2012, Falls carried to Joshua Tree sheets of heavy linen that he had hand-dyed in blues, pinks, and blacks. He used the fabric to wrap small boulders that he found amid the rocky landscape, and then left the bundles sitting on an isolated hillside for several months. Constant exposure to the sun and rain, and the absorption of ground salts, gradually bleached away portions of the linen; the blazing sunlight also "burned" the outline of the boulder into the fabric, leaving behind a ghostly circular shape. Falls describes these photogram-like works as "formed over time, rather than captured in an instant."

Christopher Phillips

>> Born in
San Diego, 1984

Lives and works in
Los Angeles

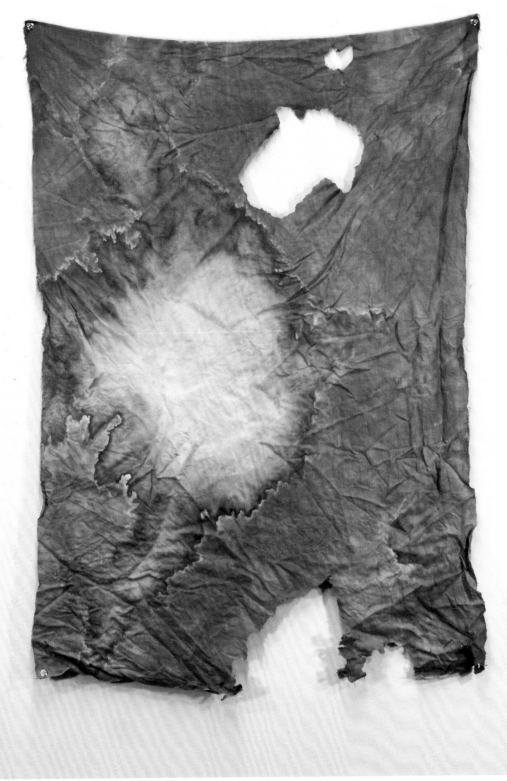

Untitled (green, Joshua Tree, CA), 2011/12

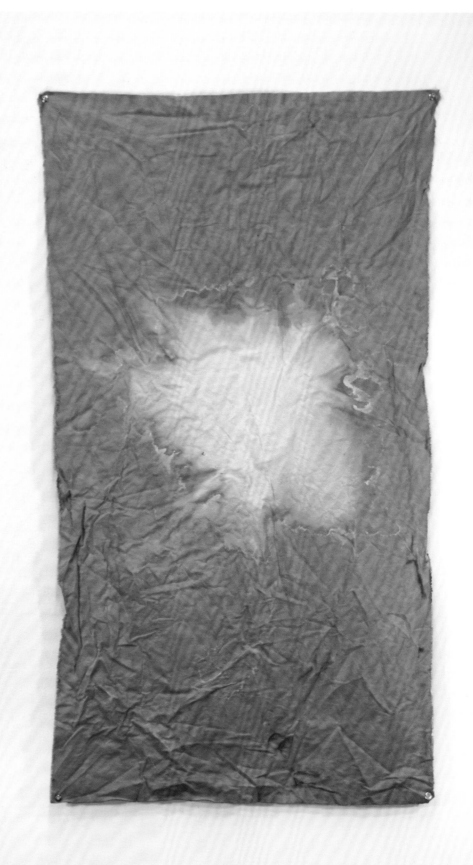

*Untitled (orange 2,
Joshua Tree, CA),* 2011/12

Untitled (pink, Joshua Tree, CA), 2011/12

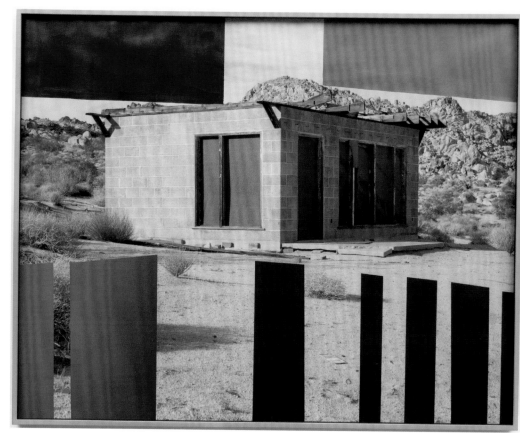

Untitled (Joshua Tree house, fuchsia), 2012

Untitled (painted picture 3), 2011

Untitled (painted picture 5), 2011

Untitled (Joshua Tree house, yellow), 2012

Lucas Foglia

During the years that straddled the 2008 financial crises, photographer Lucas Foglia explored a network of off-the-grid communities tucked away in the woods and fields of the American southeast. Some of these communities are united by a passion for preservation of ancestral ways of hunting, foraging, and building; others adhere to self-styled religions or are motivated by predictions of global economic collapse. Though diverse in their ideologies, all of their members left cities and suburbs to structure their lives on the principle of self-reliance.

Foglia himself was raised on a small Long Island farm surrounded by suburbia, where his family grew most of their food and bartered for other essentials. He was particularly interested in the ways these Americans negotiate their rustic lives, adapting aspects of the modern world to suit their values. In addition to using new technologies like solar panels, wind turbines, or micro-hydroelectric systems to produce power, many of the communities embrace the ways in which our contemporary networked culture facilitates knowledge sharing. They maintain their own websites, and through the web organize seasonal gatherings for an open exchange of skills like herbal medicine, shelter building, or hide tanning.

Foglia published this work in *A Natural Order* (2012), his first monograph. The book included a commissioned zine called *Wildfoodin'*, anonymously authored by a member of one of the communities Foglia documented. Part journal, part survival manual, it reads like a poet's version of the *Whole Earth Catalog*, the bible for back-to-the-landers.

Aside from that 1970s social movement, Foglia's subjects describe their lifestyle with language borrowed from a variety of philosophies, from libertarianism to transcendentalism. The rich vein of self-reliance that runs through the history and psyche of the United States notwithstanding, Foglia's subjects made their choices during a unique collision between American ideologies and modern economic forces. If there is little romanticism in his images of these individuals, who often appear to live with more grit than edenic peace, their beauty lies in the recognition of human needs: to create, and to control one's destiny.

Joanna Lehan

》 Born in
Long Island, New York, 1983

Lives and works in
San Francisco

Acorn with Possum Stew, Wildroots Homestead, North Carolina, 2006

David in His Wigwam, Kevin's Land, Virginia, 2010

Homeschooling Chalkboard, Tennessee, 2008

64

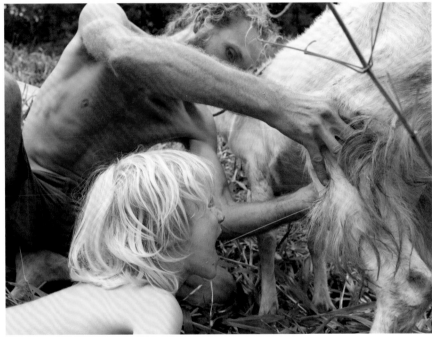

Andrew and Taurin Drinking Raw Goat's Milk, Tennessee, 2009

Venison for Canning, Tennessee, 2008

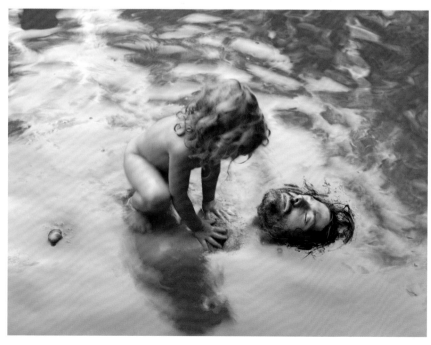

Patrick and Anakeesta, Tennessee, 2007

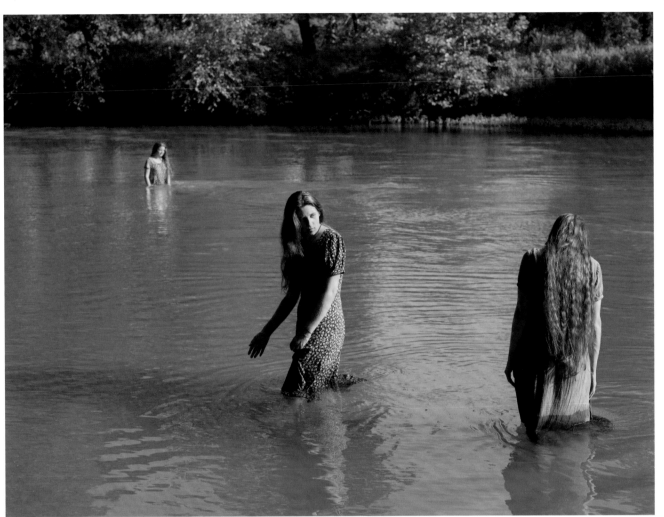

Jasmine, Hannah, and Cecilia Swimming, Tennessee, 2008

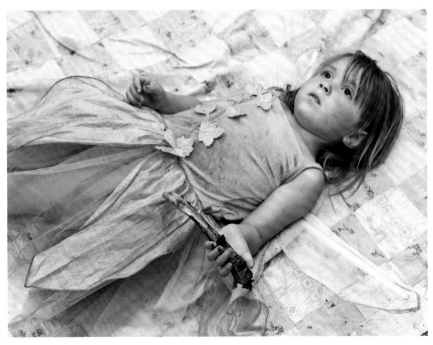

Lunea with Deer Rib, Kevin's Land, Virginia, 2008

Jim Goldberg

Since the 1970s, Jim Goldberg has explored new approaches to photographic storytelling, focusing on long-term, collaborative explorations of marginalized or neglected social groups. Based in San Francisco, Goldberg is a member of Magnum Photos and a professor at the California College of Arts and Crafts.

Known for his innovative forms of narration, Goldberg frequently integrates text written by the subjects themselves into his photography. This method of storytelling began with his book *Rich and Poor* (1977–85), an exploration of "American myths about class, power, and happiness" that juxtaposes residents of welfare hotels and affluent people photographed in their well-appointed homes, each in turn paired with hand-written texts from the subjects. In *Raised by Wolves* (1985–95), Goldberg worked closely with homeless teenagers in San Francisco and Los Angeles to create a book and exhibition that combined original photographs, texts, home movie stills, snapshots, drawings, and diary entries, as well as single and multi-channel video, sculpture, found objects, light boxes, and other elements. *Raised by Wolves* remains a signal work for its unconventional, genre-challenging approach to documentation, narration, and the relationship between artist and subject.

In 2003, Goldberg began his first major project outside of the United States, photographing in Greece, a country with a large population of undocumented immigrants. As a recipient of the Henri Cartier-Bresson prize in 2007, he was able to extend the scope of the project, traveling to many of the countries from which these immigrants arrived: Ukraine, Bangladesh, Liberia, and elsewhere. The continent-spanning portrait was published in the four-volume book *Open See* (2009). The archival scope of the project befits the enormity and complexity of the global shifts Goldberg describes, while his emphasis on the individuals and their stories—many of which are inscribed on the photographs by the migrants themselves—captures the specificity and uniqueness of each experience of dislocation.

Proof, a wall installation of contact prints from the *Open See* project, echoes the scale and immediacy of the book, as well as its departure from the narrative conventions of the traditional photo story. Goldberg explains: "*Proof* is my attempt to assemble a 'family album'; a catalogue raisonné of all of my photographic encounters during the past nine years of this project . . . On one level, this piece illuminates my working/editing process and how I use markings and notes to make sense of what I've shot. On another level, it describes the way in which I conceptually address my subject. While both the words 'contact' and 'proof' are technical photographic terms used to describe a set number of images or quickly made prints, I use them to illustrate that these are people with whom I have had *contact*, and my work perhaps acts as *proof*, certifying the existence of these individuals who would otherwise be invisible."

Leigh Tanner

≫ Born in
New Haven, 1953

Lives and works in
San Francisco

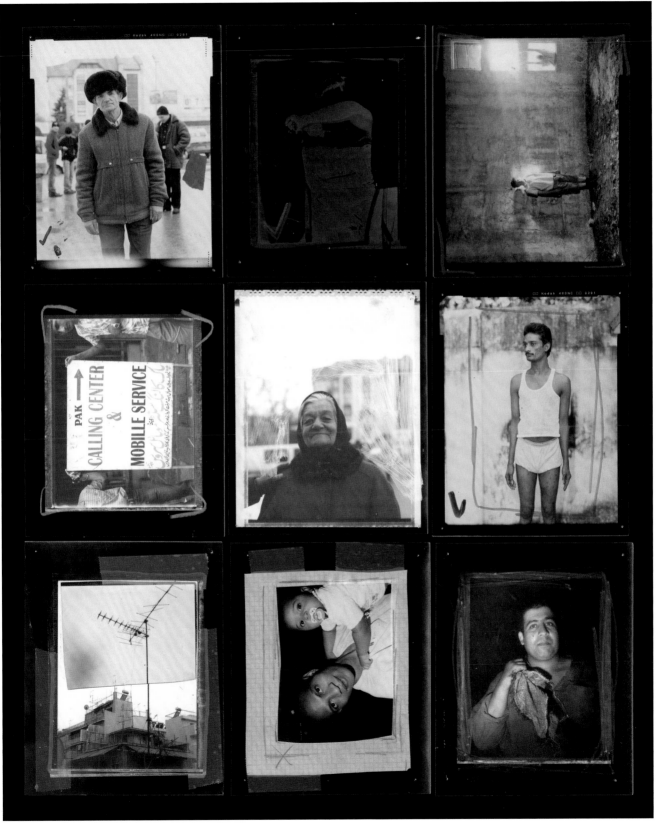

Proof (detail), 2011

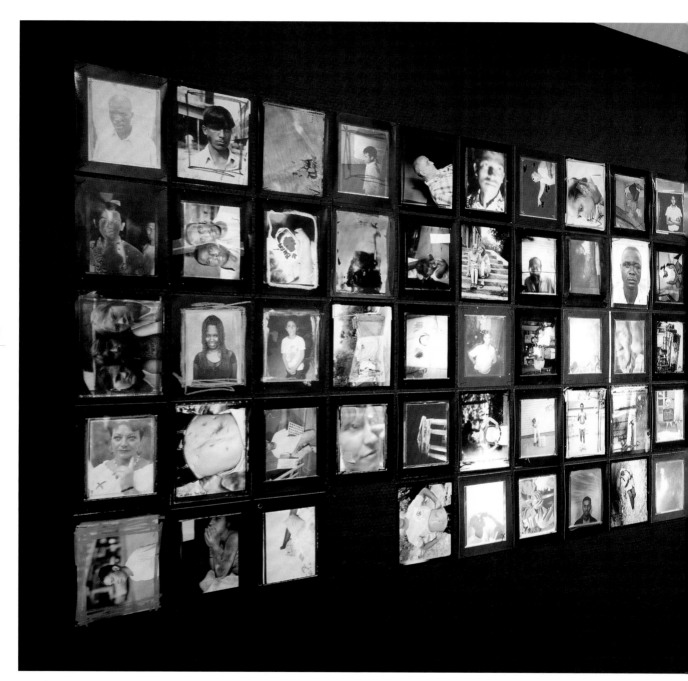

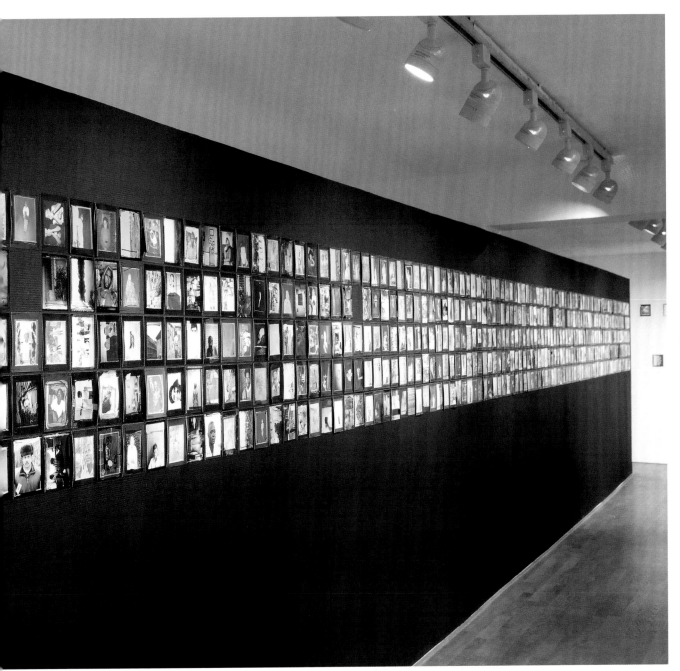

Installation, *Proof*, FOAM, Amsterdam, October–November 2010

Proof (detail), 2011

Proof (detail), 2011

Mishka Henner

In Mishka Henner's series *Dutch Landscapes* (2011), the geometric abstractions imposed on these satellite views were not rendered by the artist. Henner found these altered images on Google Earth, the free digital mapping service that supplies the Internet-enabled public detailed images of our planet via satellite imagery and aerial photography. Introduced only four years after the September 11 attacks, Google Earth offered an unprecedented level of easy-access geographic information, creating security concerns among governments who required Google—or the image suppliers that Google uses—to obscure the details of sites they deemed vulnerable. The censorship comes in various forms, from the superimposition of low-resolution or out-of-date imagery over sensitive areas, to simple blurring. In the Netherlands, the censorship was surprisingly strident—and notably beautiful.

Forms that seem to be unwitting references to Cubism or De Stijl obscured hundreds of Dutch sites, from military to municipal. Henner is interested as much in the aesthetics of these interventions as their role as historical records of a time when governments' response to terrorism has resulted in policies that are uneven, or even absurd. In the case of these images, the approach to obfuscation goes against its utility; the pleasing polygons and blobs only draw attention to the sites the government deemed too sensitive to be publicly visible. Many of these sites now appear on Google Earth without apparent manipulation, but some of these early efforts at censorship can still be viewed by tracking the history of a given site.

The geography of the Netherlands is the result of centuries of human intervention to reclaim the land from the sea and prevent the flooding of its rivers and estuaries. In his self-published book *Dutch Landscapes*, Henner points to the precariousness of the manufactured landscape of the Netherlands by including some unaltered Google Earth satellite photos alongside the altered ones. For Henner, these unaltered photos, wherein seemingly each meter of land is carved into developed parcels alongside rigorously channeled waterways, point to further irony: that the threat presented by climate change may be more real to the famously low-lying country than the hypothetical threat of terrorism.

Through 2009, Henner worked in a more traditional documentary mode—with a camera. Aided by grants from Arts Council England, he and his partner Liz Lock spent years photographing and conducting interviews in northern England, where they live, to document the postindustrial landscape and the legacy of economic decline. He considers his more recent work no less documentary in its urges. Compelled by the vast data and imagery archives available on the Internet, Henner performs the same sustained and obsessive searches, now in virtual space, to reflect truths about our time.

Joanna Lehan

Born in
Brussels, 1976

Lives and works in
Manchester, England

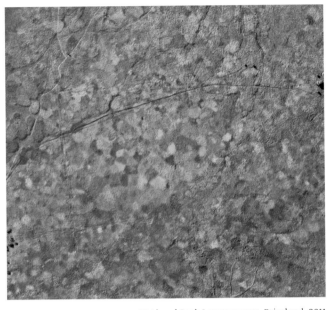

National Park Lauwersmeer, Friesland, 2011

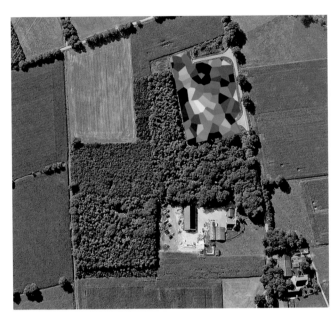

NATO Pipeline Station #1, Stokkum, Gelderland, 2011

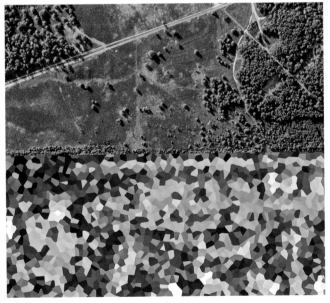

Mauritskazerne, Ede, Gelderland, 2011

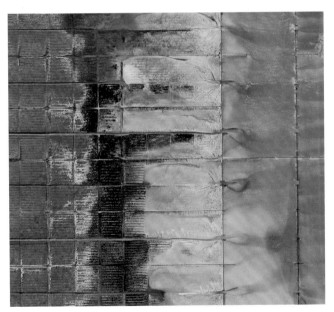

Dam Ameland, Friesland, 2011

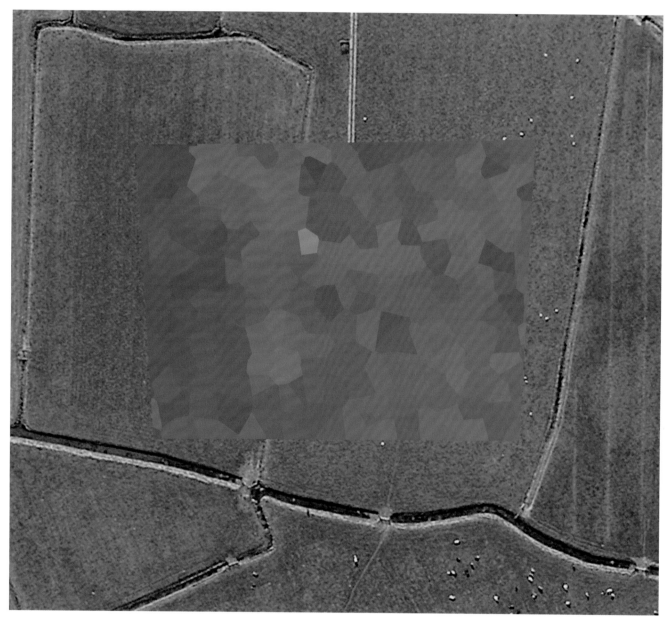

Leeuwarden Air Force Base Antennas, Friesland, 2011

Frederikkazerne, Den Haag, 2011

Unknown Site, Noordwijk aan Zee, South Holland, 2011

NATO Storage Annex, Coevorden, Drenthe, 2011

Staphorst Ammunition Depot, Overijssel,
2011

St. Haagsche Schoolvereeniging, Den Haag,
2011

Thomas Hirschhorn

Thomas Hirschhorn is an artist of vehement opinions, messages, and ideas. He creates installations, sculpture, and collages that explosively mix found images—many of them violent and many of war—with an astonishing array of other materials, including store mannequins, garbage pails, beer cans, video monitors, packing tape, and philosophical tracts. His works are messy, excessive, intelligent, and energetically frightening in their passionate excess. He takes on the modern world and dismembers it, revealing something of its essential madness.

Hirschhorn is a prolific artist and has created a number of installations; some he calls "sculptural pavilions," others are "precarious monuments." The latter are complicated, massive projects composed of his usual set of fragile materials and dedicated to philosophers and artists he feels deserve to be honored and remembered, such as Georges Bataille, Baruch Spinoza, and Gilles Deleuze. In New York in 2013, he will create one devoted to the leftist Italian political theorist Antonio Gramsci, who died after a long imprisonment by the Italian Fascist dictator Benito Mussolini.

Political violence and its effects is one of his overarching subjects and Hirschhorn has used war images and commercial photographs, sourced from magazines and the Internet, in many of his installations and collages. Fashion and advertising images form a nightmare continuum with photos of war and death in collages that erupt with inky cascades of tears and blood. In *Outgrowth* (2005), 131 world globes are tightly packed onto seven wooden shelves. Along the edges of the shelves are mounted hundreds of found photographs of conflict. Using the brown shiny packing tape he favors, Hirschhorn creates bulbous distortions on the surfaces of the globes that suggest both violent eruptions and the bandaging of the world's wounds. *Touching Reality* (2012), shown in the ICP Triennial, is a video of powerful but deceptive simplicity. In it, a hand scrolls through a series of particularly violent images taken from the Internet and displayed on an iPad, sometimes pausing, sometimes enlarging a detail, at other times moving very rapidly. Many of the images are so graphic that some viewers will find it difficult to look at them, which is one of Hirschhorn's points.

In answer to the challenge that such images are too graphic, Hirschhorn in 2012 wrote an impassioned text, "Why Is It Important—Today—To Show and Look at Images of Destroyed Human Bodies?" The images are of uncertain provenance and quality, he explains, because mostly witnesses or rescuers rather than professional photojournalists take them. The news media do not print such pictures and therefore people are distanced from the effects of violence. Yet these images are redundant because so many bodies have been destroyed and continue to be destroyed in the redundancy of human cruelty. We live in a world of cold facts that obscure the irreducible truth of human destruction. For these and other reasons, it is imperative that we *do* look at them, according to Hirschhorn. Only the viewer can judge.

Carol Squiers

>> Born in
Bern, Switzerland, 1957

Lives and works in
Paris

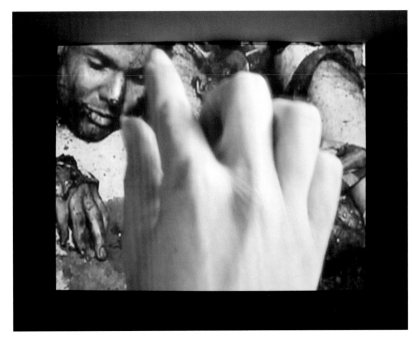

Installation, *Touching Reality*, La Triennale, Palais de Tokyo, Paris, April–August 2012

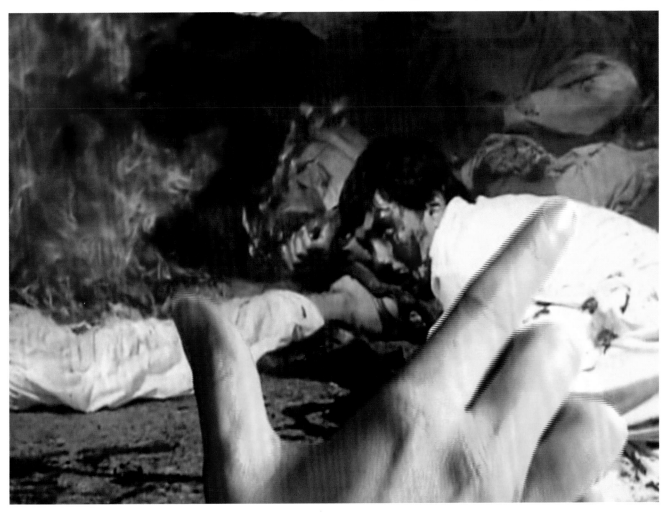

Touching Reality, 2012

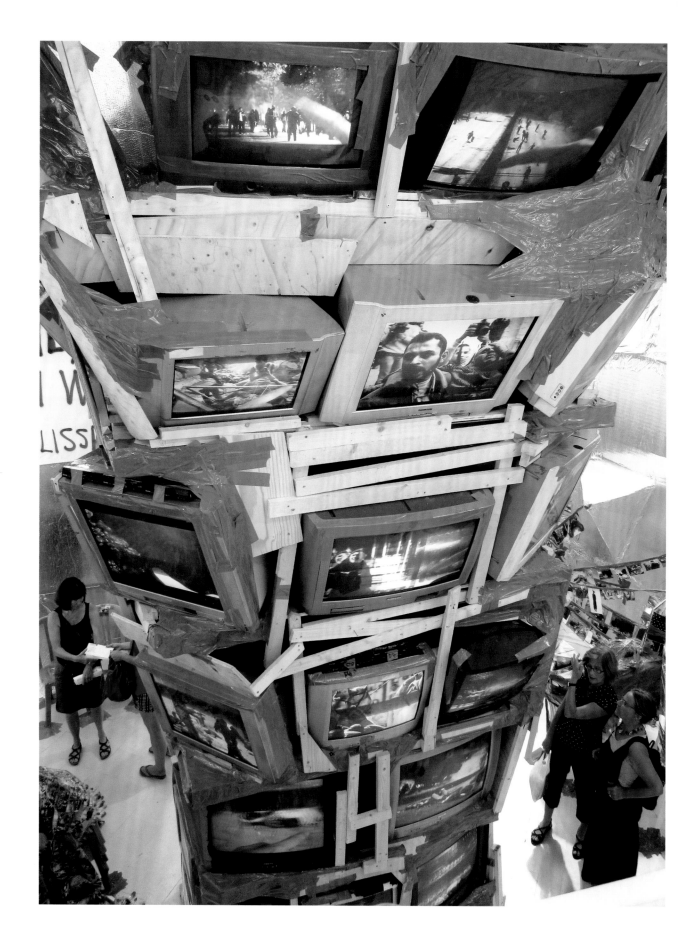

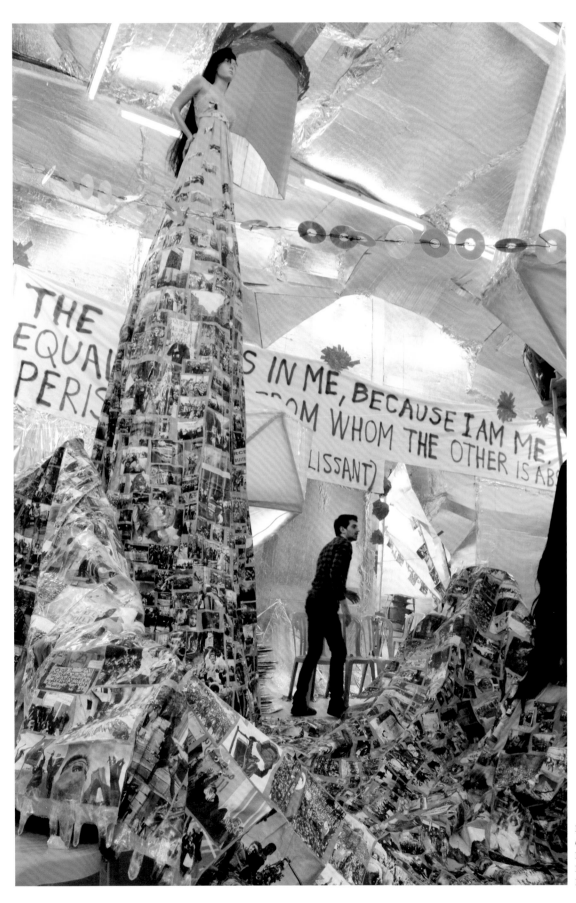

Installation, *Crystal of Resistance*, Swiss Pavilion, Venice Biennale, June–November 2011

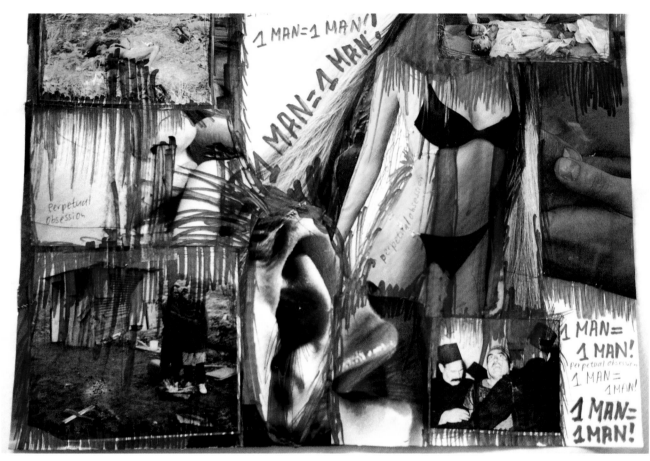

Perpetual Obsession, from the series *One Man = One Man*, 2001

Collage-Truth no. 53, 2012

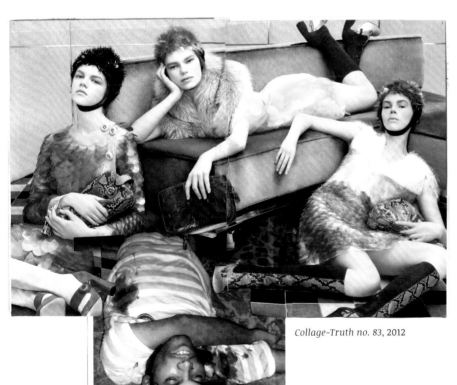

Collage-Truth no. 83, 2012

Elliott Hundley

Elliott Hundley makes large, dazzling, and incredibly complex collages that blend ancient tragedy, modern consumer culture, found materials, and photography rooted in personal relationships. He studied painting, sculpture, and printmaking as an art student, but began taking photographs for private reasons, to make pictures of a boyfriend who would be returning to his home in Italy. The direction of his art changed when he began making small dioramas using those photographs. Ever since, photography has played an important and sometimes central role in his work.

For a number of years, his major subjects have been gleaned from the often blood-soaked and violently ecstatic tales spun out in the plays of Euripides, the fifth-century B.C. tragedian whose story lines have a curiously modern feel as they pivot around issues of deception, power, love, and death. Hundley's *Bacchae* series is based upon the question of Dionysus' paternity and the refusal of his family to acknowledge him as a deity and son of Zeus. One piece depicts the scene in which Dionysus' mother is hit by lightning as punishment for claiming Zeus was the father of her child. Another invokes the revenge of Dionysus on his cousin Pentheus, the king of Thebes. For outlawing Dionysian rituals in Thebes, Dionysus provoked the Bacchantes, a cultic group that included Pentheus' mother and aunts, into tearing the king limb from limb, a scene enacted in multiple images in *Pentheus* (2010). Hundley bridges the divide between then and now with a stunning surety, translating the stories and often doomed characters into myriad scenes using family and friends as models attired in handmade costumes holding scavenged props. He and one assistant do all the work of lighting, styling, and photographing on these shoots, which at times turn into festive events crowded with friends.

For the ongoing *Bacchae* series, Hundley's photographs of significant characters (Dionysus, Agave, Pentheus, Semele) were printed as large inkjet images on rice paper mounted on a building material called sound board. Multiple boards were then assembled into a continuous surface up to 24 feet long on which Hundley built a series of vignettes based upon a particular scene in a play using small figures cut out from his photographs, along with pieces of Euripides' text and hundreds of other found images (of diamond rings, Pueblo pottery, whitewall tires). All of them are affixed with various types of pins, along with magnifying glasses, pieces of metal, plastic, wire, and even found paintings. The encrusted surfaces of the pieces can extend up to eighteen inches from the support, creating topological currents of pins that sweep across the support, bearing images and found materials that seem to shimmer in mid-air.

Hundley's collages have evoked an array of art-historical precedents, from Hieronymus Bosch to Victorian collagists to Jackson Pollock. Hundley himself looks to the work of Cy Twombly and practitioners of staged photography such as F. Holland Day and the rediscovered James Bidgood, who married the glamour photography of the 1940s and 1950s to gay male erotic imagery. There is little, however, that can account for the fantastically complex orchestrations of image and affect that Hundley brings to life.

Carol Squiers

≫ Born in
Greensboro, North Carolina, 1975

Lives and works in
Los Angeles

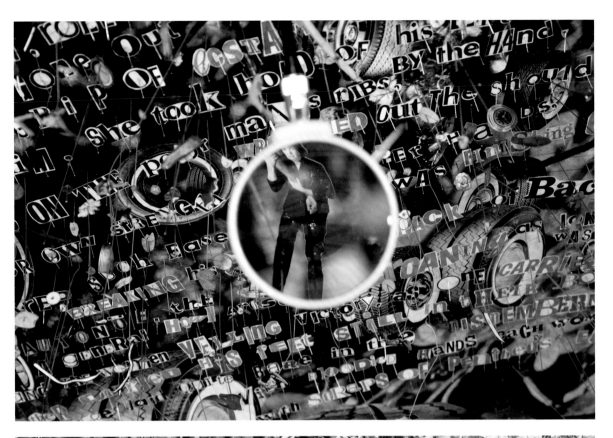

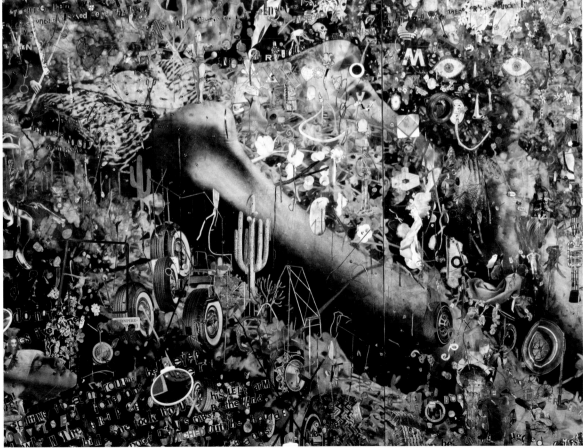

Pentheus
(details), 2010

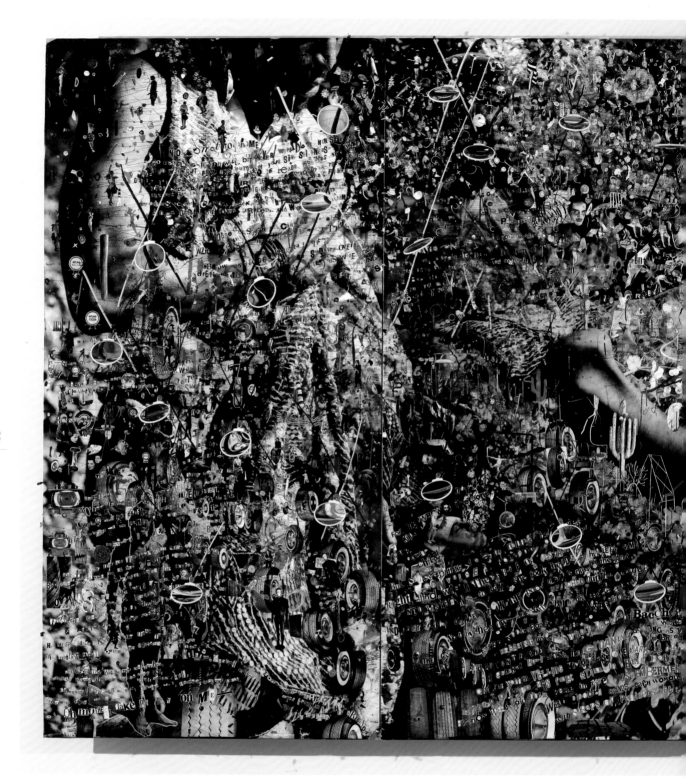

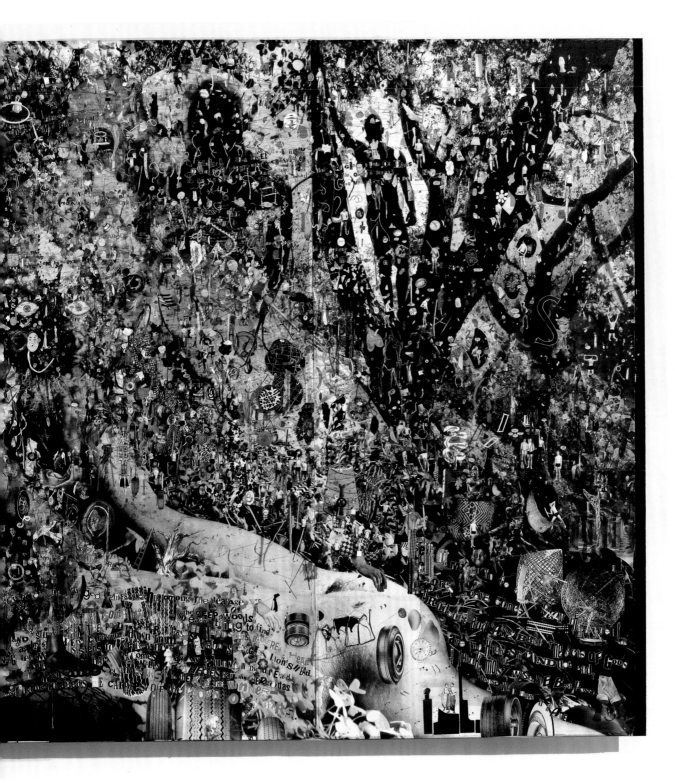

Pentheus, 2010

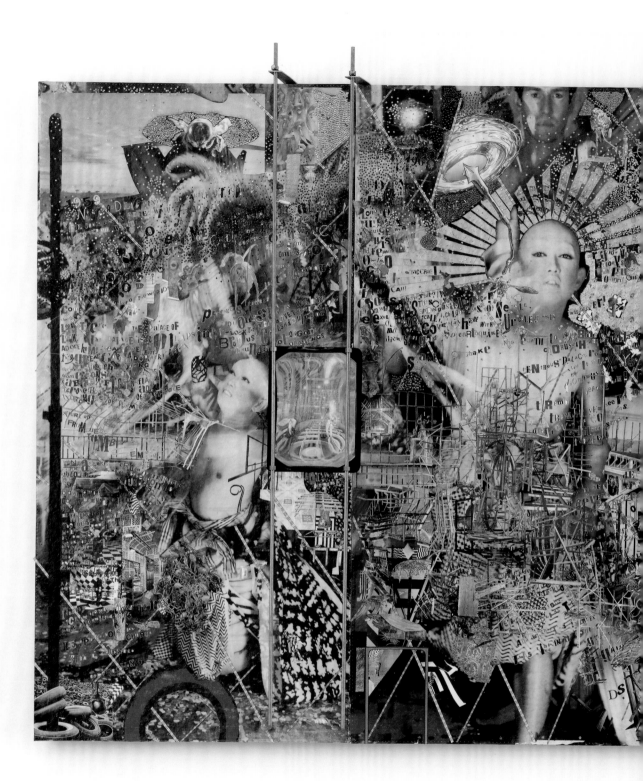

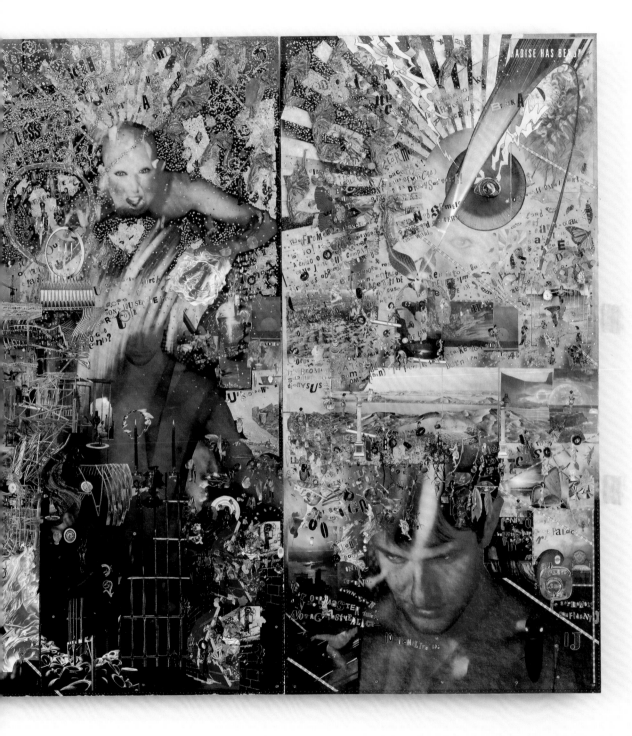

the high house low!, 2011

Oliver Laric

In the age of the Internet, the artistic maneuver known as "appropriation" has taken on an entirely new and more expansive life. Artists now have a vast network of not only photographs but every other type of visual production, both moving and still, at their disposal. Oliver Laric, an artist of notable subtlety and intelligence, accesses these digital universes to make works of art that take many forms, some as videos, others as two- or three-dimensional objects made with 3-D digital modeling or other digital methods and technologies, all of them available on his website. In a time of extreme visual cacophony, Laric has turned digital sourcing into a restrained, scholarly, and enigmatic art form.

Since 2009, Laric has produced a mutating series of videos named *Versions*, in which seemingly unrelated images, along with obviously related images, flow with lyrical disjunction one into the other. For *Versions*, Laric ranges across cultures, products, and pictures, as they appear or are portrayed on the web, clipping out still and moving digital images—of car accidents, an animated Shinto shrine, American sports photos, Japanese sports comics, Warner Brothers cartoons, Iranian missile tests, ancient Greek sculpture and ancient Roman copies. The images are presented against a plain white ground, the photographer's equivalent of a white seamless backdrop. Each has a voiceover that delivers a soothingly plumy yet robotic reading of texts addressing notions of originality and remix in tones suggesting a professional actor delivering instructions on seatbelt safety or fire drills. *Versions* is a series of extended visual essays on the proliferation of the copy and the improbability of authenticity or singularity in human culture, a project that makes its point in a weirdly singular manner. And although attention spans differ in our distracted populace, *Versions* will repay an active viewer who interrogates the ideas and images that Laric presents.

The missile photographs released by the Iranian Revolutionary Guard, for example, are pure propaganda that induced political panic in the West. The photos appeared in 2008 as part of an effort by Iran to convince world leaders that it possessed powerful missiles that could reach Israel. The "original" photograph showed the launching of four missiles, but had been crudely Photoshopped to add the fourth missile to a photo that only had three. Soon a torrent of images were posted online, festooned with escalating numbers of missiles that mocked the Iranians' rudimentary digital retouching. Laric traces the proliferation of these altered images, some of which made the front pages of newspapers, sifting them into an enigmatic continuum that includes great books, iconoclasm, Sun Tzu, furniture design, soccer match memes, and animated movies.

In an interview, Laric talked about how posting an early video made him realize that his website "is not a space of representation but of primary experiences." Laric, in a particularly convincing way, is among those challenging the notion of the "real," the terms of materiality of the art object, and the proper site of artistic contemplation.

Carol Squiers

Born in
Innsbruck, Austria, 1981

Lives and works in
Berlin

Versions, 2012

Versions, 2012

Versions, 2012

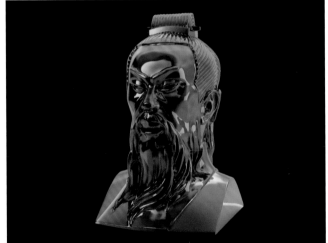

Versions, 2012

Versions, 2010

Versions, 2012

Versions, 2012

Versions, 2010

Versions, 2012

Versions, 2012

Andrea Longacre-White

Andrea Longacre-White belongs to a generation of artists who, having grown up with digital technology and the Internet, are busily extracting new image-making possibilities from them. Longacre-White was a high-school student when she was first introduced to Photoshop and videomaking. Today she feels that the habit of experiencing images primarily through digital screen displays has become deeply ingrained in our culture, so much so that artists must take it into account as an essential part of making and exhibiting art.

Since completing an MFA at London's Royal College of Art in 2005, Longacre-White has devised a host of ingenious image-making processes that put digital cameras, scanners, iPads, and MacBooks to unexpected uses. She may start with an ink-jet print of a photograph and then cut, fold, tear, or crease it before scanning or rephotographing the print. After successive generations of digital and physical transformation—what she calls "the constant looping between the physical and the digital worlds"—recognizable objects disappear from the image, and digital artifacts, dust spots, and fingerprints left on scanner surfaces become more prominent. While the resulting monochrome prints at first appear to be wholly abstract, they are in fact never completely devoid of human traces.

In works made especially for a specific exhibition site, Longacre-White sometimes starts by making her own digital photographs of the gallery's architectural spaces. After emailing the images to herself, she brings one up on her iPad, which she then places on the bed of a scanner. Because the iPad interprets the heat from the scanner as a human touch-command, it tries to shift to another page. The resulting scanner image captures the progressive alteration of the original jpeg as it passes through this and other unpredictable electronic transformations. Longacre-White describes the framed works that are finally hung in the gallery space not as site-specific but as "site-responsive."

For the ICP Triennial, Longacre-White has made a group of new works that respond to the interior space of ICP's galleries, which were originally designed by the celebrated New York architectural firm Gwathmey Siegel.

Christopher Phillips

>> **Born in**
Radnor, Pennsylvania, 1980

Lives and works in
Los Angeles

Picture of Blackout, 2012

Pictures of Blackout Tiled, 2012

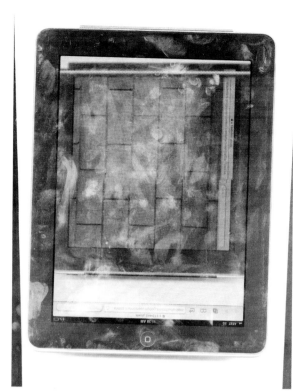

Pad Scan, 2012

Untitled (Image Pile), 2012

Picture of Pad Scan, 2012

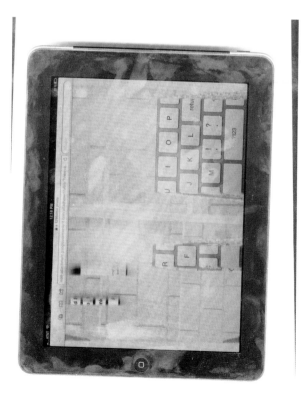

Pad Scan, 2012

*Pictures of Blackout
Tiled* (detail), 2012

Ceiling (detail), 2011

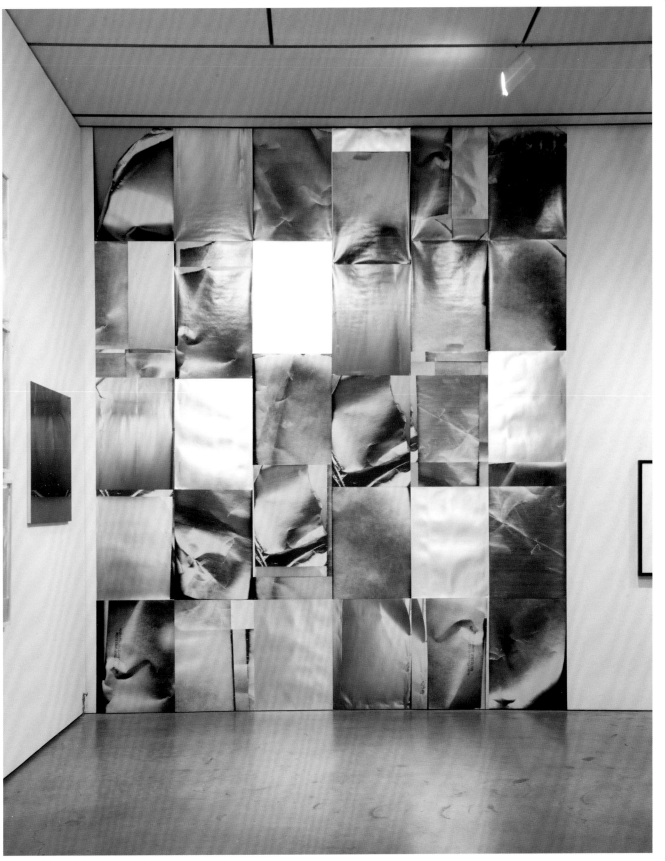

Ceiling, 2011

Gideon Mendel

Since 2007, Gideon Mendel has tracked the worsening floods around the world, one of the most destructive and visible signs of climate change. He does not photograph the weather the way the broadcast media does, as a spectacular disaster that leads at 11. Or the way a photojournalist would, arriving to record the most dramatic effects of torrential rains, howling wind, and obliterating waters. Instead, he waits several weeks or more before departing for flood zones, looking for what happens to daily life in the countries he visits—which include the U.K., India, Australia, Pakistan, Thailand, Haiti, and Nigeria—when the flood is technically over. What he has found is that in poor countries, the floods take a long time to recede, help is not often on the way, and a majority of people don't have the time or resources to clean up and rebuild. Instead, they must carry on their lives, making dinner, selling produce, or grilling takeaway meats with the floodwaters in their homes, stores, and temples of worship, sometimes thigh-deep in brackish water for weeks or months at a time. The photographs are mostly frontal portraits of single figures or small groups facing the camera, standing in the boundless water and wearing expressions that telegraph a range of emotions, from stoicism to desolation. It is a project he calls *Drowning World*.

In September 2012, a month before parts of the Caribbean and the United States were scoured by Hurricane Sandy, Nigeria experienced the worst flooding in fifty years; by November, 363 people had been killed, more than 18,000 injured, and 2 million displaced. The story was barely reported in the U.S. Mendel arrived in Nigeria six weeks after the heaviest flooding. He photographed with a Rolleiflex, a video camera, and his iPhone, using a square-format 6x6 iOS app that mimics the Rollei's format. Then he posted the latter images to Instagram, the first time he has used the platform for a long-term project (see pages 112–13). Those streamed images drew a lot of attention to the Nigerian floods online, especially when they were re-tweeted by BBC correspondent Paul Mason.

Certainly Mendel's career as a photojournalist informs his current and other long-term projects. He started out in 1983 photographing the battles, deaths, and funerals of the anti-apartheid struggle in South Africa, where the camera was officially declared an instrument of insurrection. A decade later, he turned his attention to AIDS and the effects it was having in Africa, not only its ravages but also the tremendous work of activists who fought for AIDS education and treatment. As he continues his interventionist project, he has taken on another killer: climate change, which millions have already experienced first hand.

Carol Squiers

Born in
Johannesburg, 1959

Lives and works in
London

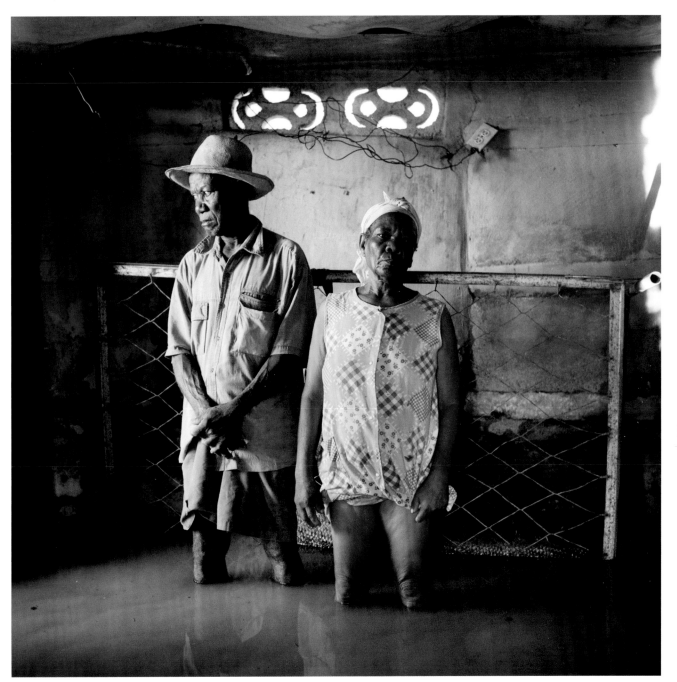

Christa and Salomon Raymond Fils, Decade Village, Haiti, September 2008

La-awtip Lamjaitong, Taweewattana district, Bangkok, Thailand, November 2011

Lalo Davi, Pir-muhammadpur village, Bihar, India, August 2007

Margaret Clegg, Toll Bar village near Doncaster, UK, June 2007

Shopkeeper Suparat Taddee, Chumchon Ruamjai Community, Bangkok, Thailand, November 2011

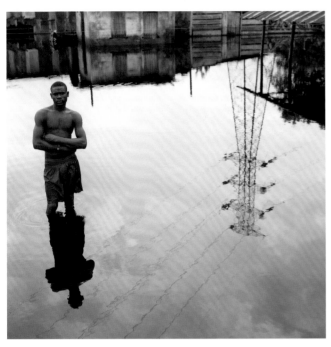

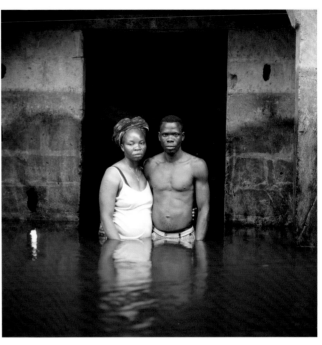

Dalami, at a flooded goat farm and butchery, Ahoada, Rivers State, Nigeria, November 2012

Victor and Hope America, Igbogeni, Bayelsa State, Nigeria, November 2012

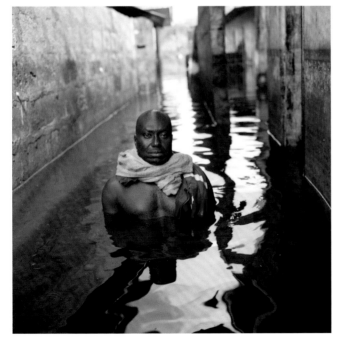

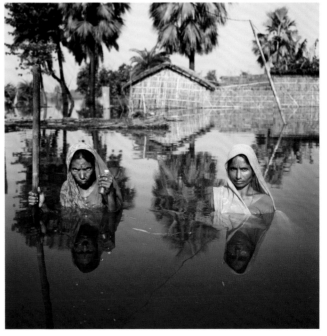

Ratmas Ebiarohon, Igbogeni, Bayelsa State, Nigeria, November 2012

Chinta and Samundri Davi, Salempur village near Muzaffarpur, Bihar, India, August 2007

View from the Elevated Borommaratchonnanee Road, Bangkok, Thailand, November 2011, still from the video *Living with Floodwaters*

Street scene in the Taweewattana district, Bangkok, Thailand, November 2011, still from the video *Living with Floodwaters*

Shopkeeper in the Wijit Kolnimit Community, Bangkok, Thailand, November 2011, still from the video *Living with Floodwaters*

The high point that floodwaters reached in the house of Ratmas Ebiarohon, Igbogeni, Bayelsa State, Nigeria, November 2011

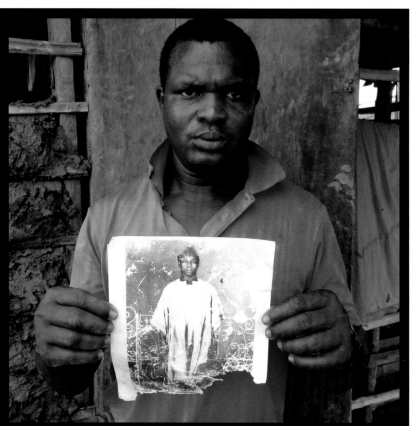

Isaac Deruy with a damaged photograph of his grandfather Umoru Bomba that he rescued as his house was flooded, Igbogeni, Bayelsa State, Nigeria, November 2011

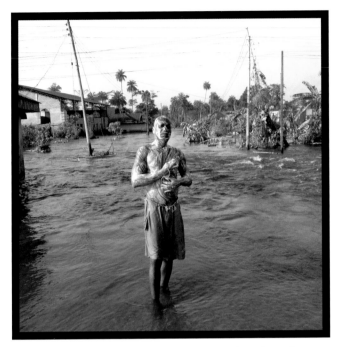

Ratmas Ebiarohon washes himself in floodwaters, Igbogeni, Bayelsa State, Nigeria, November 2011

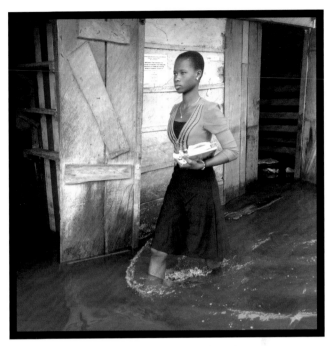

On her way to church on a Sunday morning, Igbogeni, Bayelsa State, Nigeria, November 2011

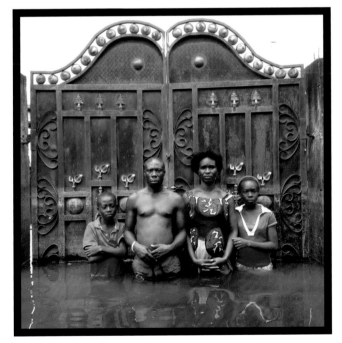

Traditional healer Joseph Edem and his wife Endurance with their children Godfreedom and Josephine, Igbogeni, Bayelsa State, Nigeria, November 2011

Swimming in a flooded town, Igbogeni, Bayelsa State, Nigeria, November 2011

Luis Molina-Pantin

Combining conceptual and documentary photography, Luis Molina-Pantin uses the camera to ask what may be learned about a given cultural context from its built environment. With subjects ranging from offices in the Chelsea gallery world (*Chelsea Galleries*, 2001–6) to Latin American soap operas (*Inmobilia*, 1997), the Caracas-based artist works in the manner of a self-described "urban archaeologist," investigating questions of class, authority, and display.

In the 29 photographs that comprise the series *An Informal Study of Hybrid Architecture, Vol. 1—Narco-Architecture and Its Contributions to the Community (Cali–Bogotá, Colombia)* (2004–5), Molina-Pantin documents a surprising architectural genre that emerged in the 1980s from the fortunes amassed by profiteers of the Colombian drug trade. Posing as a real-estate photographer, he gained access to properties in communities where security and safety remain precarious even after the breakup of major drug cartels in the mid-1990s. The Parque Jaime Duque estate near Bogotá—named for its owner, a wealthy pilot suspected of involvement in the drug trade—transposes some of the Seven Wonders of the World and the Taj Mahal to a new setting in which they are rendered as kitsch. Divorced from their cultural and historical contexts and inserted into a foreign milieu, these iconic structures are transformed into free-floating symbols in a Las Vegas–like form of postmodern appropriation. In their new environment, the buildings and sculptures signify power and prestige in a generic gesture toward high culture at the same time as they call attention to the extremes of wealth distribution produced by the drug trade. Meanwhile, in Cali, a car dealership owned by a drug trafficker has been crowned by a replica of the U.S. Capitol Building, blending notions of civics and capitalism in a claim to legitimacy by association. Other subjects in the series are more mundane—high-rise office buildings and gated mansions, the sizes of which are out of proportion to their smaller-scaled environs.

Together, the images point up the extent to which the drug economy has shaped the built environment through an absurd form of hijacked cultural expression.

Margaret Ewing

≫ Born in
Geneva, 1969

Lives and works in
Caracas

Parque Jaime Duque 3, 2004–5

Vista Interior de Residencias, Cali, 2004–5

Parque Jaime Duque 1, 2004–5

CLOCKWISE FROM TOP LEFT *Grupo de Viviendas, Cali, 2004–5*

Grupo de Viviendas, Cali, 2004–5

Castillo Marroquín, Bogotá, 2004–5

Parque Jaime Duque 4, 2004–5

Rabih Mroué

As this is being written, the brutal civil war in Syria nears its two-year mark. The government has made it virtually impossible for any news media to cover the conflict. In response, Syrian activists have become citizen journalists, uploading videos to YouTube and using Twitter, Skype, and Facebook to report on the violence to the outside world. Syria may be the most dangerous place on earth for news media employees and citizen journalists alike. *The Pixelated Revolution*, a video and photographic installation by the artist, actor, and playwright Rabih Mroué, considers the peculiar plight of the ordinary person who tries to document these extraordinary circumstances.

Mroué grew up in Beirut during the fifteen years of war that devastated Lebanon, beginning his practice as an artist in 1990 after the fighting finally ceased. His work has long dealt with the intersection of representation, daily life, war, and narration and often takes the form of what he calls a nonacademic lecture, a performance that is also videotaped. Many of his works are based on found photographs and the ways they may be interpreted or misunderstood long after they are taken.

The Pixelated Revolution was inspired by a friend's comment as the violence in Syria escalated: that the Syrians are filming their own deaths. Mroué began searching the Internet for photographs and videos and found a number of them that were shot with a cell phone from the point of view of a protester or an ordinary citizen. In one case, the cameraperson focuses on what appears to be a soldier holding a gun and seems to watch until the soldier spies the person who is watching him. The soldier raises his gun, shoots, and seems to hit the person who has been filming as the camera falls into an unfocused spiral. Neither the fate of the cameraperson nor the way the video made its way onto the web is explained. By using the footage, Mroué places himself in a position similar to all the news media outlets that have used citizen journalist reportage during this conflict in that such material usually cannot be verified.

As an artist who has been schooled in theater, Mroué also puts these guerrilla videos into a theatrical context, invoking the ten stringent rules of Dogme 95, a Danish filmmaking collective. Mroué found what he felt were distinct, perhaps uncanny, and sometimes controversial correspondences between the Danes and Syria's citizen journalists. Among them are that the shooting must be done on location, that the camera must be handheld, and that the director must not be credited. Most of all, Mroué understood that the protesters had to confront the dangers of their activities and that they were working out their own rules as they shared advice and information on Facebook and then returned to their bloody, unfinished revolution.

Carol Squiers

》 **Born in**
Beirut, 1967

Lives and works in
Beirut

Blow up 4, 2012

Blow up 6, 2012

Blow up 3, 2012

Blow up 2, 2012

Blow up 7, 2012

Blow up 1, 2012

The Pixelated Revolution, 2012

Wangechi Mutu

Fashioning photographic fragments into elaborate collages that appear seamless despite improbable and jarring juxtapositions, Wangechi Mutu investigates representations of black women as "exotic" others in the European-American context. Her hybrid creatures, crafted from a wide range of sources, including ethnographic books, *National Geographic*, medical illustrations, and pornography, challenge binary oppositions that seem to no longer apply in the age of globalization. The breakdown of traditional terms of gender and race, analog versus digital, and nature versus culture is manifested in imagery that rejects clear definition within a landscape of blurred boundaries.

Mutu's method is a careful reflection of her subject matter; as she explains, "Displacement anxiety and a fractured identity are implied in my drawings; there are mutilations and awkward attachments in the collage work." Widely known for large works on glossy Mylar that shimmer with glitter and the illusion of liquidness, Mutu also works on a smaller scale, using found illustrations that themselves become collage elements. In a recent series of collages, pages from a medical textbook serve as the base layer for hybrid creatures in which the *insides* of bodies are now as prominent as the outsides, and pink and gray muscle striations dominate a fusion of pinup fragments, plants, and animal images.

More recently, Mutu's questioning of the norms of representation has opened onto the problem of identity in a world where migration—and the elusiveness of "home"— has become widespread. In *Family Tree* (2012), thirteen collages are connected by a network of lines, arrows, and names in an illustrated version of her own genealogy. The series begins with *Bird Perched on Ribcage*, isolated on the installation's far left. Its penciled label identifies it also as "Prodigal Daughter," in one of the artist's most direct references to her own experience in her work. In an explosion of anatomical and taxonomic order, a human ribcage emerges from the figure's forehead, legs from its nose and mouth, and the heads of animals from its ears and crown. It suggests that identity, too, has been blown apart, now subject to input and bombardment on every level, from every direction.

Margaret Ewing

≫ **Born in**
Nairobi, 1972

Lives and works in
Brooklyn, New York

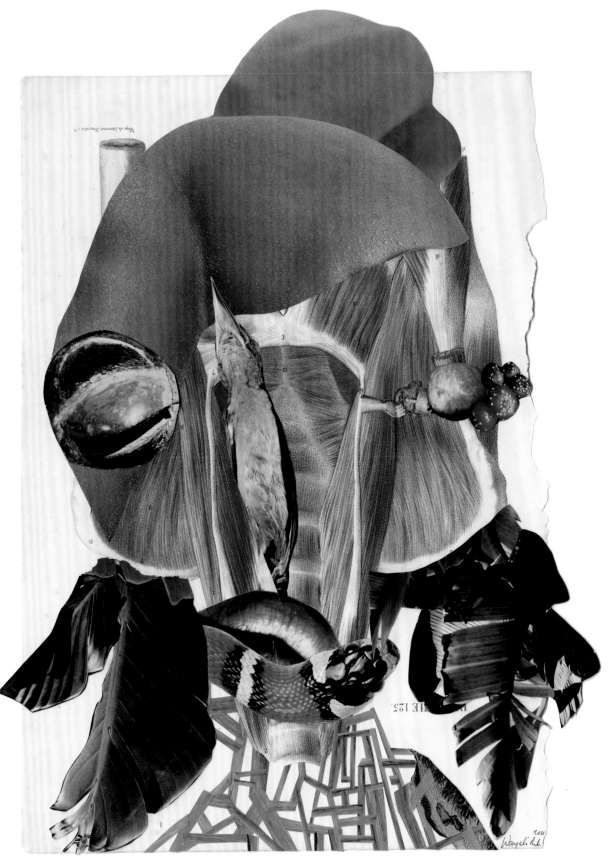

Sick Bird Syndrome, 2011

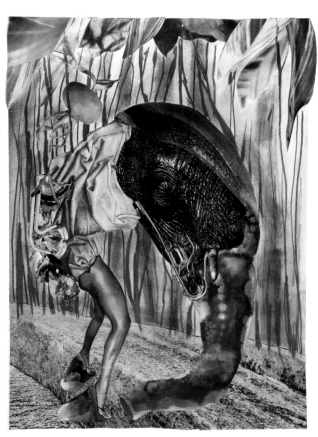

Kichwa Kubwa, 2011

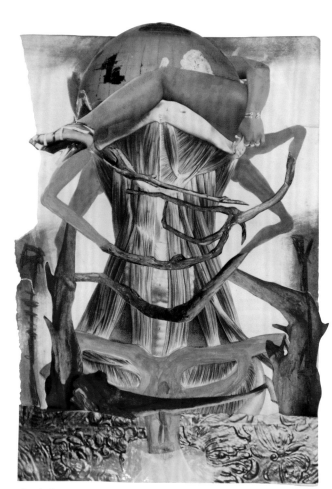

The Birth, 2011

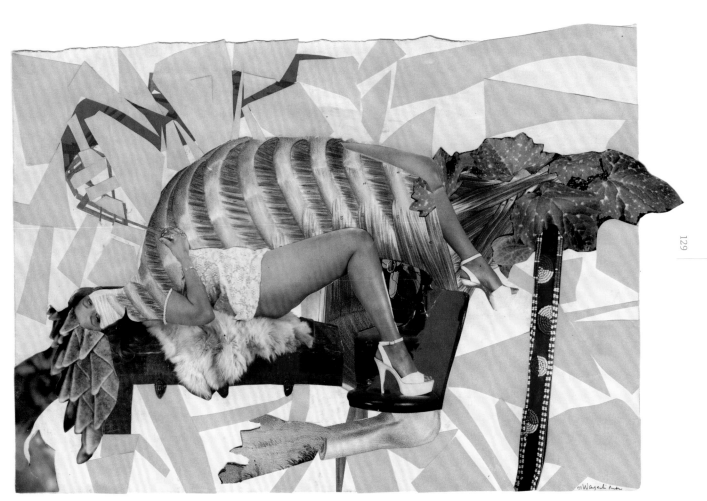

The History of My Heavy Heart, 2011

Family Tree, 2012

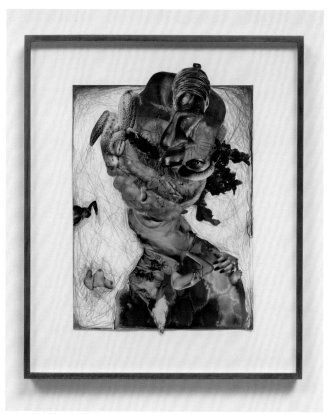

Family Tree (detail), 2012

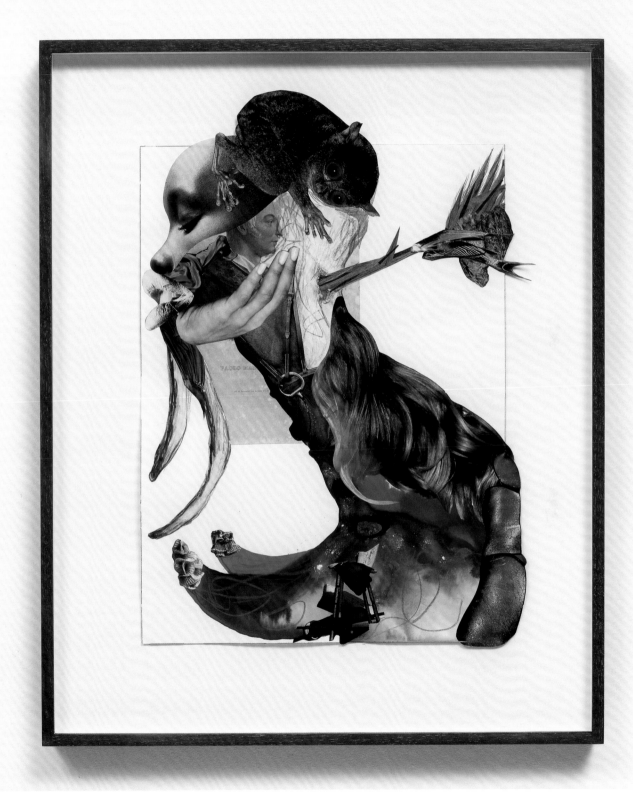

Family Tree (detail), 2012

Sohei Nishino

Sohei Nishino began his remarkable *Diorama Maps* while still an undergraduate at the Osaka University of the Arts. Assigned to make a group of contact sheets from 35mm negatives and then to choose the best images for enlargement, he became fascinated with the overall impression of simultaneously seeing so many small images. He soon set to work on his first *Diorama Map*, shooting 150 rolls of film on long walks through Osaka. He printed contact sheets from the negatives, cut out all of the individual frames, and then began to freely arrange the tiny prints in an enormous collage. The entire process took a year. The result is by no means a geographically accurate map of Osaka, but instead an astonishingly complex imaginative reprocessing of Nishino's experience of the city.

In 2005, a year after graduation, Nishino was awarded the prestigious Canon New Cosmos of Photography award for his first group of *Diorama Maps*. Encouraged by that recognition, he pursued the project on a global scale. His subjects have included such world cities as Tokyo, New York, London, Paris, Hong Kong, and Istanbul. Wherever he travels, his process remains largely the same. He spends roughly a month exploring a city on foot with his camera, shooting up to 10,000 images, of which he may use 4,000 or so. He photographs iconic buildings and cityscapes (often seen from an elevated viewpoint) as well as people he encounters in the street. Determined to carry out every step of the process by hand, he slowly and painstakingly assembles enormous collages that can measure up to seven feet in width. He exhibits equally large prints that he makes by photographing the finished collage, so as to remove all visible traces of his handwork.

Although Nishino depicts the urban spaces of our twenty-first century, the handcrafted look and jostling perspectives of his works suggest a premodern, almost medieval sensibility. The artist says that he prefers ancient maps to contemporary ones, because the old mapmakers were forced to use their imagination to visualize uncharted lands. In an age when Google Earth is organizing images of the entire planet within the seamless coordinates of a virtual map, Nishino reminds us that human imagination is needed to bring meaning to such accumulations of information. His *Diorama Maps*, as he describes them, reveal "simply the city as seen through the eyes of a single individual, a trace of the way in which I walked through it, an embodiment of my awareness, a microcosm of the life and energy that comprises the city."

Christopher Phillips

>> **Born in**
Hyogo, Japan, 1982

Lives and works in
Tokyo

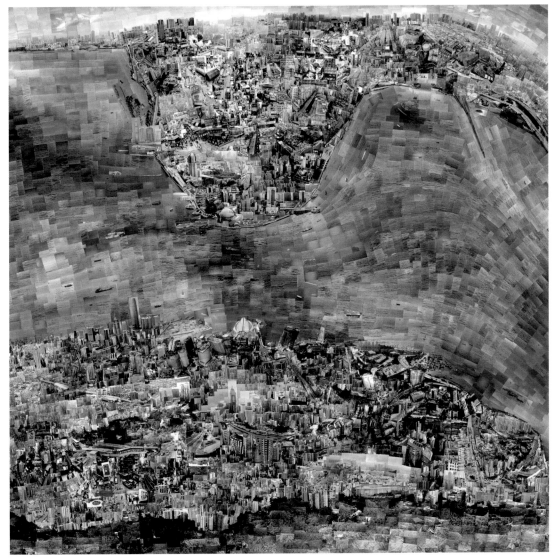

Hong Kong, from the
series Diorama Maps,
2010

Installation, Contemporary Japanese
Photography vol. 10, Tokyo Metropolitan
Museum of Photography, December 2011–
January 2012

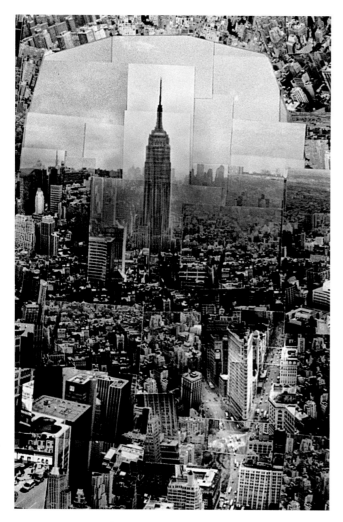

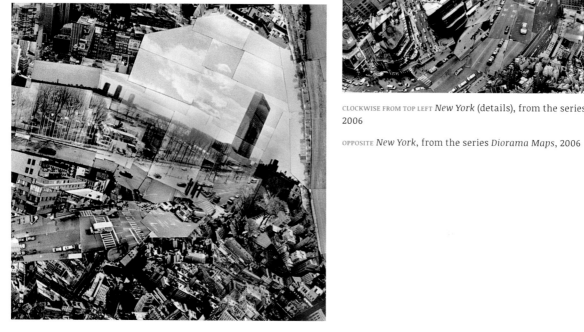

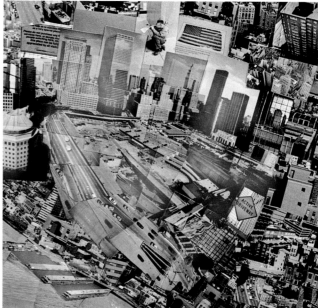

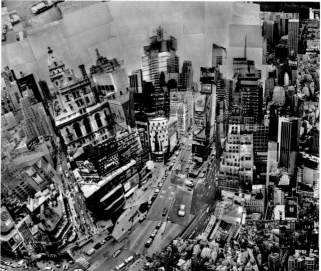

CLOCKWISE FROM TOP LEFT *New York* (details), from the series *Diorama Maps*, 2006

OPPOSITE *New York*, from the series *Diorama Maps*, 2006

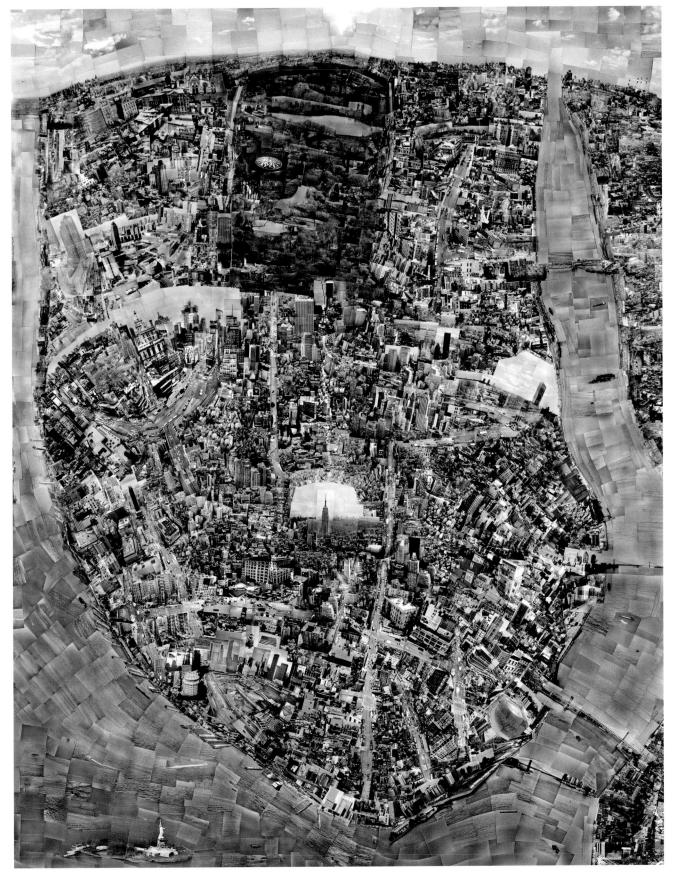

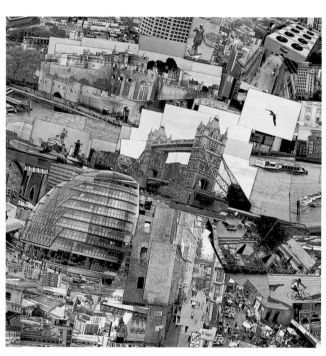

London (detail), from the series *Diorama Maps*, 2010

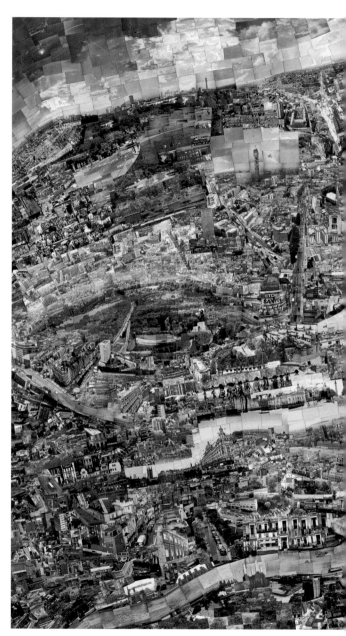

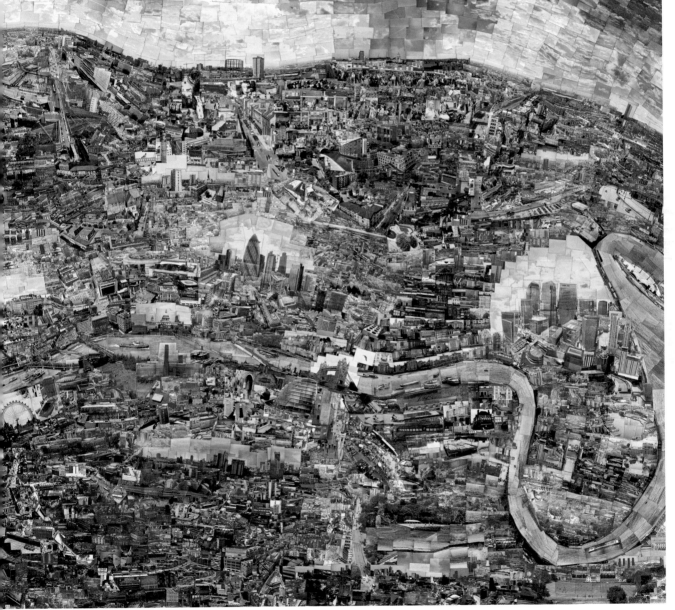

London, from the series *Diorama Maps*, 2010

Lisa Oppenheim

In Lisa Oppenheim's work, analog equipment such as projectors and gelatin silver paper is repurposed for use in the digital era. Her photographs and films, made since 2005, often begin with Internet research, which Oppenheim considers central to her practice. The results are hybrids of generations and technologies that are neither wholly dependent on their forerunners nor untethered.

For her series *Smoke* (2011), Oppenheim sourced photographs of fire from web databases such as Flickr and the Library of Congress and cropped the images to isolate their clouds of smoke. She made transparencies of the altered image in Photoshop and exposed them onto new photographic paper using the light of a small butane torch or matches. Variations in timing, the transparency used, and studio debris such as dust register in her photographs as subtle gradations that morph in successive frames.

Without horizons or people in the frame, the reexposed smoke billows become abstractions with obvious reference to Alfred Stieglitz's *Equivalents*. Unlike Stieglitz, however, Oppenheim preserves the context in titles taken directly from the source photographs' captions. Names such as *Billowing. As we were driving up to Norfolk yesterday I saw the Enfield fire; where a Sony distribution center set ablaze by rioters was just pouring out smoke over the motorway. The sheer amount of smoke was quite surprising, and today smoke was still covering the motorway. I feel such despair at people who have taken to looting; so angry at the destruction people can cause, 2011/2012 (Version V)* allude to the calamitous source of the fire; others cite oil tanker explosions and volcanos. By drawing attention to the geopolitical origins, her works become metaphors to convey the urgency of the originals while maintaining their integrity as contemporary interpretations.

Oppenheim's appropriation of photographs from web-based archives highlights the broad agency of the contemporary image collagist or Google user in the age of the image's presumed versatility. Acknowledging the subjectivity and circuitousness of her process, she explains that her research entails a long, haphazard chain of affinities and associations. The final product is "dislocated and abstracted," abstraction here indicating a process in a "cultural moment defined by this meandering accumulation of information." Through her work, Oppenheim refuses the possibility of objective image distribution. The series *The Language of Flowers* (2011), comprised of photograms made with colored bands of light and flower bouquets, is loosely based on her study of Victorian codes signified by these bouquets but renders them in a charged contemporary visual language. By reinterpreting them through time, space, and new technologies, Oppenheim's work reveals the lack of neutrality in ostensibly documentary archives.

Kelly Cannon

Born in
New York, 1975

Lives and works in
New York

A Handley Page Halifax of No. 4 Group flies over the suburbs of Caen, France, during a major daylight raid to assist the Normandy land battle. 467 aircraft took part in the attack, which was originally intended to have bombed German strongpoints north of Caen, but the bombing area was eventually shifted nearer the city because of the proximity of Allied troops to the original targets. The resulting bombing devastated the northern suburbs, 1944/2012 (detail), 2012

Man holding large camera photographing a cataclysmic event, possibly a volcano erupting, 1908/2012 (version XI), 2012

Billowing. As we were driving up to Norfolk yesterday I saw the Enfield fire; where a Sony distribution centre set ablaze by rioters was just pouring out smoke over the motorway. The sheer amount of smoke was quite surprising, and today smoke was still covering the motorway. I feel such despair at people who have taken to looting; so angry at the destruction people can cause, 2011/2012 (tiled version II), 2012

A Handley Page Halifax of No. 4 Group flies over the suburbs of Caen, France, during a major daylight raid to assist the Normandy land battle. 467 aircraft took part in the attack, which was originally intended to have bombed German strongpoints north of Caen, but the bombing area was eventually shifted nearer the city because of the proximity of Allied troops to the original targets. The resulting bombing devastated the northern suburbs, 1944/2012 (detail), 2012

Man holding large camera photographing a cataclysmic event, possibly a volcano erupting, 1908/2012 (tiled version III), 2012

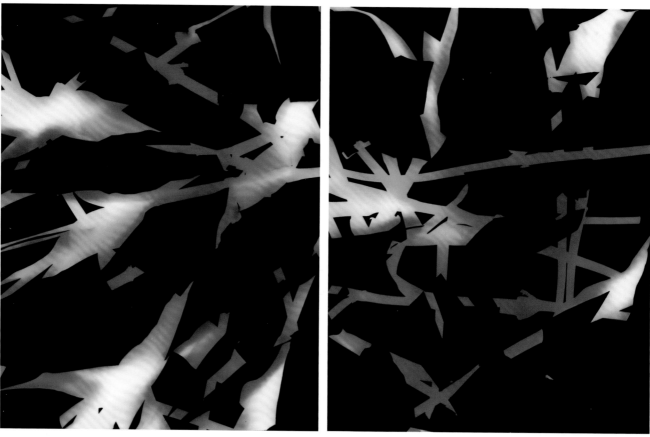

Perfect Lovers V, from the series *The Language of Flowers*, 2011

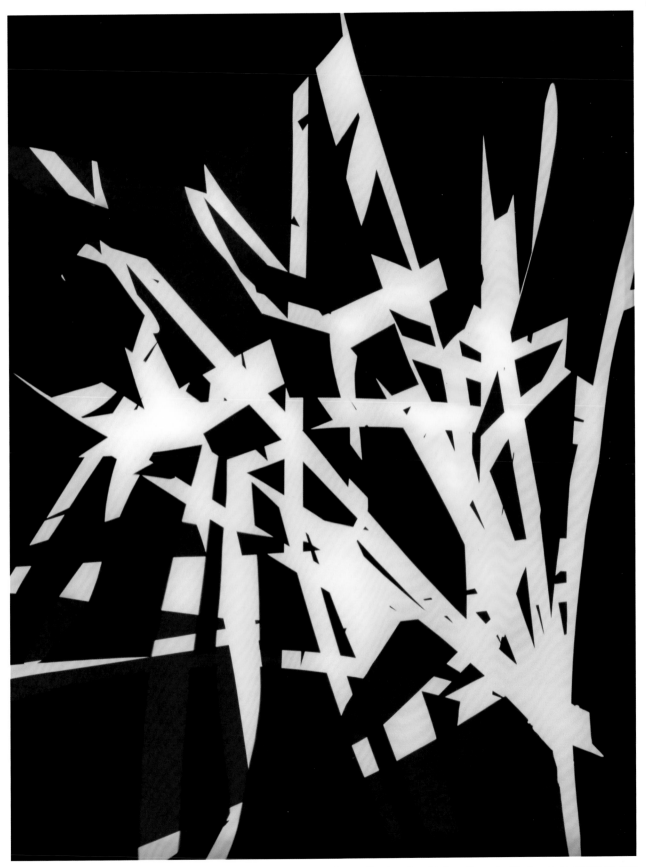

Egotism and Formality (Narcissus) I, from the series *The Language of Flowers*, 2011

Trevor Paglen

Artist and author Trevor Paglen has an unusual background. He grew up on military bases in the United States and Wiesbaden, Germany; received an MFA from the School of the Art Institute of Chicago; and earned a doctorate in geography from the University of California at Berkeley. All three—the military, art, and geography—conjoin in Paglen's unprecedented work.

While in Berkeley, Paglen began photographing top secret, or "black," military facilities, many located in remote areas of the American West, just as President George W. Bush was ramping up the highly secretive War on Terror. Such facilities are strictly off-limits to civilians; many do not appear on maps, and also, quite literally, cannot be seen by what Paglen calls the "unaided eye" because one cannot get close enough to them. He developed a novel technique incorporating telescopes that he calls "limit-telephotography," which allows him to capture such sites from a considerable distance, in essence making the invisible visible. These photographs are enthralling, and chilling. Some are nearly abstract, with hints of landscape and buildings. Some are hazy and blurry, resulting from heat, light, dust, and atmospheric conditions, but this blurriness is effective: images at the edge of cognition underscore how little we know of powerful forces operating in the world. Paglen's *The Fence (Lake Kickapoo, Texas)* (2010) takes its title from the colloquial name for the powerful radar system that surrounds the U.S., which tracks aircraft and warns about incoming missiles. The microwave frequencies of this system, which extends into space, are normally invisible to the human eye. Collaborating with an amateur radio astronomer, Paglen devised a way of shifting the system's electromagnetic waves into a visible spectrum. The resulting photo is gorgeous, with its red, orange, white, and black tones, but it is also stark evidence of an exceptionally strong national "border" that most people don't know exists.

The Fence will be presented in ICP's Triennial, along with several photographs of drones, unmanned aerial surveillance and weapons delivery vehicles much in the news recently because of their deadly activity in the Waziristan region of Pakistan. In Paglen's photos, drones are not elsewhere, but instead right here, in this country, for instance on training missions above Nevada. Engulfed by immense and eventful skies, which recall various Romantic paintings as well as Alfred Stieglitz's cloud photos, the aptly named Predator and Reaper drones look tiny and fragile, but also terrifying and lethal.

With work that combines technology, politics, nature, and art, Paglen has recently turned his attention to satellites and outer space. For *The Last Pictures* (2012), he assembled 100 photographs chronicling our historical moment, micro-etched them on an ultra-archival disk, and mounted the disk on a satellite. Launched in the fall of 2012, this satellite will orbit in perpetuity, longer than the earth's life span. Finding the disk, a future civilization may be able to deduce something of what life was like on a planet that no longer exists.

Gregory Volk

Born in
Maryland, 1974

Live and works in
New York

The Fence (Lake Kickapoo, Texas), 2010

Large Hangars and Fuel Storage, Tonopah Test Range, NV, Distance ~18 miles, 2005

Workers, Gold Coast Terminal, Las Vegas, NV, Distance ~1 mile, 2007

Chemical and Biological Weapons Proving Ground, Dugway, UT, Distance ~ 42 miles, 2006

Untitled (Predators; Indian Springs, NV), 2010

Untitled (Reaper Drone), 2010

Drone Vision, 2010

Walid Raad

Walid Raad's artistic practice has expanded and enriched our ideas about what the subject of contemporary art can be and how that subject can be represented. He produces complex and nuanced work that defies easy summation. The work is grounded in his own lived experience, both in Lebanon during the Lebanese wars of 1975 to 1990, and as an expatriate. Raad left Lebanon and moved to the United States while in his teens. From afar he followed his native country's ordeals through news coverage and news from his family and as often as possible he returned home.

But his work is hardly autobiographical in any traditional sense. Rather, in his art he almost invisibly traces the personal outward to the social, historical, political, and cultural effects and responses that are generated by the violence, greed, and brutality of war in all its forms. Some of those pieces display a doubting wit. In *Let's be honest, the weather helped* (1998/2006), he used brightly colored adhesive dots to mark the photographs he took of bullet-riddled buildings, each hue corresponding to the ammunition manufacturer's color codes. Among his innovative strategies was the decision to work for a long period under the rubric of the Atlas Group, an alleged artist's collective. So mysterious was this entity that many people remained unsure of who or what the Atlas Group was for quite a while after its work gained international attention. The primary activity of the Atlas Group was to construct an archive of various types of printed and visual documents that were created in order to investigate how events of extreme violence were lived, experienced, and represented, as Raad puts it, in fiction and nonfiction. In referencing the harsh realities of daily life in Lebanon during a crucial phase of its history, the work also promoted reflection on how history is conceived, narrated, written, and imaged.

For the ICP Triennial, Raad is exhibiting new work from the ongoing project *Scratching on Things I Could Disavow: A History of Art in the Arab World*. Since 2007, he has been exploring the extraordinary proliferation of new arts institutions, schools, museums, and international exhibitions in the Arab world. Doha, Sharjah, and Dubai have become destinations for those involved with contemporary art and ambitious building programs have been undertaken in Abu Dhabi by the Guggenheim Museum of Art, New York University, and the Louvre. Raad's photographs, an excerpt from *Preface to the third edition* (2013), concern a few of the 294 objects from the Louvre's new Islamic wing in Paris, which will be loaned to the Louvre Abu Dhabi sometime between 2016 and 2046. In Raad's Triennial piece, he proposes that some of the objects might undergo various unanticipated changes that may be literal but may also be either aesthetic or purely psychological. Ultimately, the artist is questioning the ways in which culture is deployed, defined, and disseminated across political, social, economic, and cultural boundaries that have been drawn, sometimes for centuries, in very different ways. What is the fate of art in times of great change? What happens to the culture that receives it, and what gets lost in translation?

Carol Squiers

150

>> Born in
Beirut, 1967

Lives and works in
New York

Aiguière dite de Charlemagne / Casque de Saint-Denis

Vaisselle, figures / Aachen 1000-1015
Fer / Cristal de roche, monture en or
H. 24 cm / H. max. 38,5 cm
MS 830

Preface to the third edition: Plate I, 2013

Pyxide d'al-Mughira

Espagne, probablement Madinat al-Zahra (Cordoue), 357 H/968
Ivoire sculpté, bleu de jais
H. 16 cm; D. 11.8 cm; épaisseur 1.8 cm, poids 580 g, poids du couvercle 296 g
Louvre

Preface to the third edition: Plate II, 2013

Coupe à Tête réliquaire poétique

Iran Rayy (?), fin Xᵉ-XIIᵉ siècle
Stuc à décor gravé; traces de polychromie
H.B.3,5 cm; L. 116,7 cm
MAO 1937

Preface to the third edition: Plate III, 2013

	Weight	Le...
Cartridge	504.59	2
Case	72.21	1.
Bullet	362.87	8
Paper-disc	0.05	00.
Powder*	50.48	

*Black

Let's be honest, the weather helped (Egypt), 1998/2006–7

HANDLE.

Let's be honest, the weather helped (Belgium), 1998/2006

Nica Ross

Nica Ross uses photography, video, and lighting to create immersive installation and performance pieces. Prior to entering the ICP-Bard MFA program, she worked for three years as a photographer and producer at a San Francisco–based BDSM and fetish porn company. In addition to creating her own photographic and video work, Ross co-hosts, with Savannah Knoop and Nath Ann Carrera, a monthly audio and video event, WOAHMONE, in New York City. There she presents her own live video performances as well as a wide variety of works by invited visual artists. She is also involved with Joshua Light Show in producing light installations, and is a member of the 3-Legged Dog Media & Theater Group.

For her live video projections at WOAHMONE and elsewhere, Ross acts as a VJ alongside collaborating DJs. Working from her laptop, she layers and loops ten or more moving-image streams chosen from her personal archive of obscure cult films, vintage porn, and YouTube clips. Of these improvised performances before a dance-club audience, she says, "I control every aspect of the videos, reediting them, changing color, speed, etc. But with so many elements to control, I am bound to lose it, and that's my favorite part."

As part of the ICP Triennial, Ross is organizing three live performance events that will take place during the course of the exhibition. The first will be a collaboration with Joshua Light Show members and other invited artists. For the second, an evening of VHS screenings, she will be joined by WOAHMONE DJs Knoop and Carrera; they will present an evening of music and visuals that reflect queer social and sexual history. In the final event, Ross and invited musicians and visual artists will invent in real time an audiovisual game based on an algorithmic relation between images, light, and sound.

Christopher Phillips

Born in
Tempe, Arizona, 1983

Lives and works in
New York

WOAHMONE

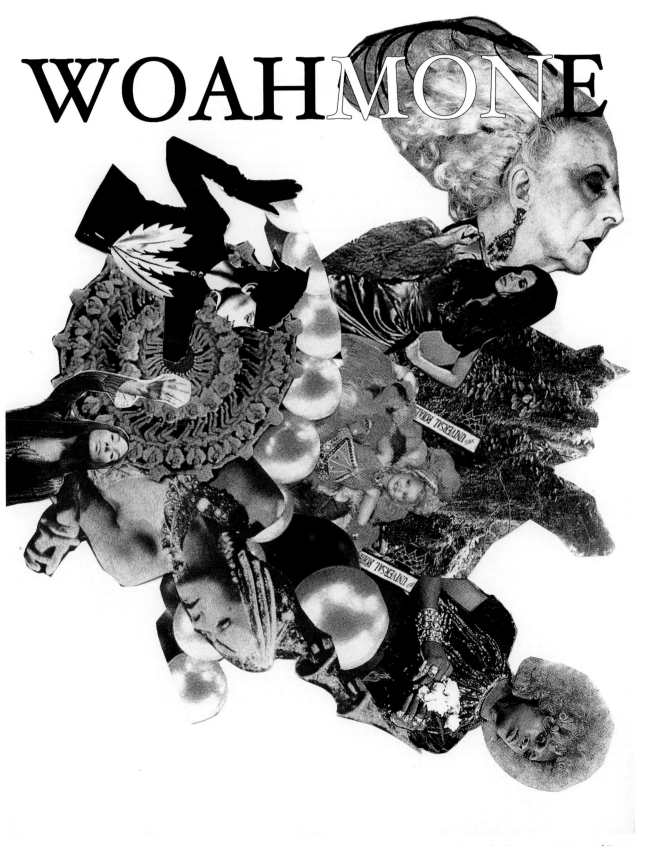

Flyer by Savannah Knoop and Nath Ann Carrera for WOAHMONE, a monthly party thrown by Nica Ross, Carrera, and Knoop

WOAHMONE, a monthly party thrown by Nica Ross, Nath Ann Carrera, and Savannah Knoop, 2011

Still from a live VJ performance at WOAHMONE, a monthly party thrown by Nica Ross, Nath Ann Carrera, and Savannah Knoop, New York, 2012

Performance, *Holding the Post for All My Selenas*, International Center of Photography MFA Studios, Long Island City, New York, 2012

Set-up for *Holding the Post for All My Selenas*, International Center of Photography MFA Studios, Long Island City, New York, 2012

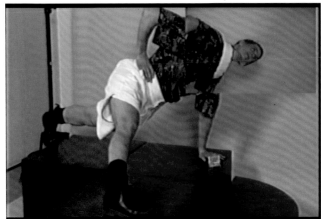

Performance featuring Savannah Knoop, *Holding the Post for All My Selenas*, International Center of Photography MFA Studios, Long Island City, New York, 2012

Performance, *Holding the Post for All My Selenas*, International Center of Photography MFA Studios, Long Island City, New York, 2012

Michael Schmelling

Michael Schmelling first encountered photography through his parents' basement darkroom and his mother's collection of nineteenth-century images of the American West. Since studying photography at New York University and taking on initial photojournalistic assignments for the Associated Press, he has worked for a long list of commercial and editorial clients. Deeply involved with the music scene, he was the principal photographer for *The Wilco Book* (2004), and in 2010 published *Atlanta*, the result of a three-year exploration of that city's hip-hop culture. Schmelling continues to work on idiosyncratic personal projects that have resulted in such highly regarded photo books as *Shut Up Truth* (2002), *The Week of No Computer* (2008), and *The Plan* (2009).

Schmelling's photographs in the ICP Triennial are drawn from the nearly 500 images that appear in *The Plan*. Over a period of several years, he accompanied on their rounds the members of an unusual New York company called Disaster Masters, which specializes in bringing order to the terminally messy dwellings of compulsive hoarders, as well as offering a regimen of post-cleanup clutter counseling. Schmelling's casual, snapshot-like photographs not only provide an archaeology of decades' worth of stubbornly preserved cultural detritus, but also furnish poignant insights into the psychology of disposophobia—the inability to throw things away.

Although the photographs were originally made in color, Schmelling realized that the cost of publishing a book with a large number of color reproductions would be prohibitive. Because he wanted *The Plan* to mirror its subject in containing an almost out-of-control accumulation of images, he decided to reproduce the photos on inexpensive newsprint paper. By turning the book itself into a kind of ready-to-toss object, Schmelling dares readers to recognize and face down their own obsessive impulse to hang onto random stuff.

Christopher Phillips

Born in
Pittsburgh, 1973

Lives and works in
New York

Untitled (Appendix 2), from the series *The Plan*, 2005–9

Untitled (Books 2), from the series *The Plan*, 2005–9

Untitled (Astoria 21), from the series *The Plan*, 2005–9

Untitled (Dusty 17), from the series *The Plan*, 2005–9

Untitled (Brando 9), from the series *The Plan*, 2005–9

Untitled (Dallas 2), from the series *The Plan*, 2005–9

Untitled (Elmhurst 28), from the series *The Plan*, 2005–9

Untitled (Sing Sing 4), from the series *The Plan*, 2005–9

Untitled (Washington 25), from the series *The Plan*, 2005–9

Untitled (Appendix 007), from the series *The Plan*, 2005–9

Untitled (Books 3), from the series *The Plan*, 2005–9

Untitled (Appendix I), from the series *The Plan*, 2005–9

Hito Steyerl

Hito Steyerl's video-based practice investigates the consequences of the unreliability of images in a world of mediated representation. Trained in Tokyo and Munich, with a Ph.D. in philosophy from the Academy of Fine Arts, Vienna, the artist poses questions about truth versus fiction and the friction and slippage between an original and its free-floating copy. In her essay "In Defense of the Poor Image," Steyerl (also a prolific writer) defines a new type of image that travels freely around the globe, now detached from its originating context. "The poor image is a copy in motion. Its quality is bad, its resolution substandard. . . . The poor image has been uploaded, downloaded, shared, reformatted, and reedited. . . . [It] is an illicit fifth-generation bastard of an original image. Its genealogy is dubious." Available for appropriation and re-purposing, its meaning has become unmoored and open to manipulation.

In the video *November* (2004), she explored the instability of meaning as images circulate via print, television, and the Internet. The narrative stems from Steyerl's chance discovery of a protest poster in Berlin, on which the face of a childhood friend, Andrea Wolf, has become the improbable symbol of the PKK (Kurdistan Workers' Party) in its decades-long fight for Kurdish autonomy. In a pastiche of video and filmic elements that alternately jump forward and trace back, the artist harnesses the story's inherent uncertainty in the means of its telling. By the end, Steyerl herself becomes implicated in the construction of meaning, her own image a pawn in a seemingly authoritative television documentary of a street demonstration in Berlin. "In *November*," she observes from experience, "we are all part of the story, and not 'I am telling the story' but 'The story tells me.'"

Steyerl's *Abstract* (2012) revisits Wolf's story, pursuing ties between German weapons and the Turkish government, believed to have been responsible for the air and ground assault on Wolf's group, during which she was captured and killed. Juxtaposing "shots" and "countershots" of weapons producer Lockheed Martin's Berlin office with the supposed site of the attack near the Turkey-Iraq border, the artist plays on similarities in the languages of film editing and combat. In this follow-up to *November*, Steyerl's iPhone assumes a leading role, itself foregrounding the ever-increasing availability of the tools of documentation and the infinite possibilities of its manipulation.

Margaret Ewing

Born in
Munich, 1966

Lives and works in
Berlin

Abstract, 2012

Abstract, 2012

A picture of war is not war.

November, 2004

Mikhael Subotzky / Patrick Waterhouse

The 54-story Ponte City building in Johannesburg, South Africa, has become a symbol of the country's post-apartheid struggles. It was built in 1976, when the surrounding neighborhood was largely white. But with the end of apartheid in 1994, many white residents fled to the suburbs. In 2007, developers bought the building with the aim of attracting middle-class black professionals, but the project went bankrupt a year later and the building was left to deteriorate. South African photographer Mikhael Subotzky and artist Patrick Waterhouse collaborated on this photographic project about the building.

The three lightboxes in *Ponte City* include photographs taken between 2008 and 2010 of every window, internal door, and television in the partially occupied building. The towering compositions echo the scale of the building itself, and the images are arranged according to the floor on which they were taken. This gridded typology brings to mind the work of Bernd and Hilla Becher and their protégés, but the *Ponte City* pictures are rooted in social documentary. A member of Magnum, Subotzky is known for gritty documentary projects such as *Beaufort West* (2006–8), in which he documented life in and around the Beaufort West Prison, and *The Four Corners* (2004), photographs of inmates of the Pollsmoor Maximum Security Prison, where Nelson Mandela was incarcerated.

The failures of Ponte City are inscribed on the building. The lightbox of internal doors trace the building's history of stalled renovations: the pink paint and ornate patterns of the doors from the 1970s are on the untouched upper stories, and the plain black wood doors, which were installed during the renovations, are on the lower floors. The photographs of windows highlight not only the 360-degree view from the circular building, but also reveal curtains, hanging clothes, or silhouettes of residents, evidence of lives being lived outside of public view. While photographing the building's windows, the artists noticed that many residents were more interested in their television screens than in vistas of the city. The third lightbox contains images of soap operas, music videos, Nollywood movies, and porn television as a means of escape from reality.

Subotzky and Waterhouse focused on various portals in Ponte City having to do with looking and access: windows looking out, doors opening in, and TV screens offering a view into the imaginary. But as the spectacular views suggest, what is visible is not always within reach, and although Ponte City is not a jail, a subject Subotzky has explored before, the building houses residents whose freedoms are limited by a failure of vision in a postconflict society.

Jean Dykstra

MIKHAEL SUBOTZKY
≫ Born in
Cape Town, 1981

Lives and works in
Johannesburg

PATRICK WATERHOUSE
≫ Born in
Bath, England, 1981

Lives and works in
Italy, England, and South Africa

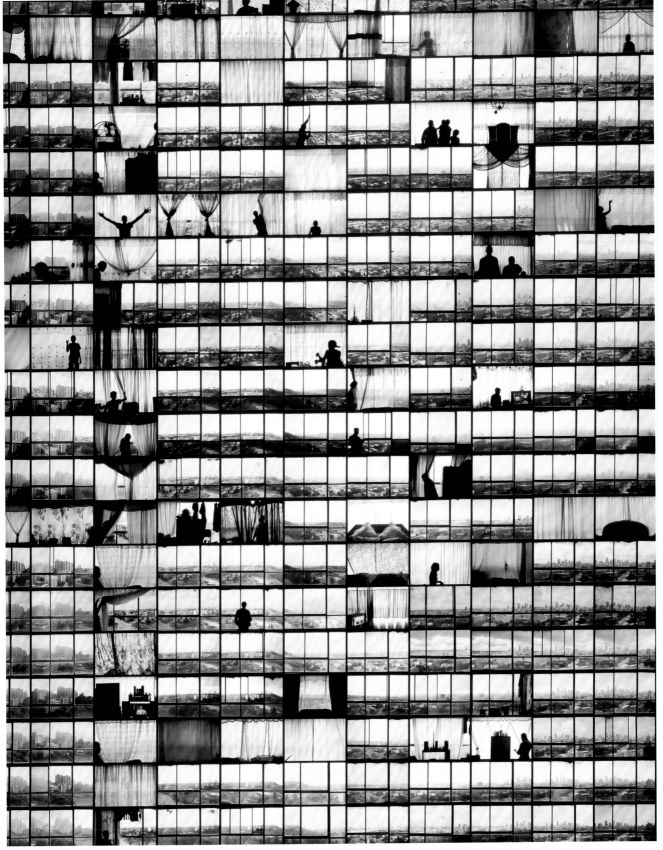

Windows, Ponte City (detail), 2008–10

Windows, Ponte City (detail), 2008–10

46/05 (Floor 46, Apartment 05), from *Windows, Ponte City*, 2008–10

44/03 (Floor 44, Apartment 03), from *Windows, Ponte City*, 2008–10

ABOVE *42/17 (Floor 42, Apartment 17)*, from *Doors, Ponte City*, 2008–10

RIGHT *36/18 (Floor 36, Apartment 18)*, from *Doors, Ponte City*, 2008–10

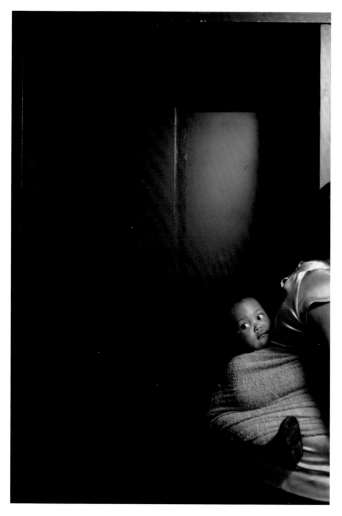

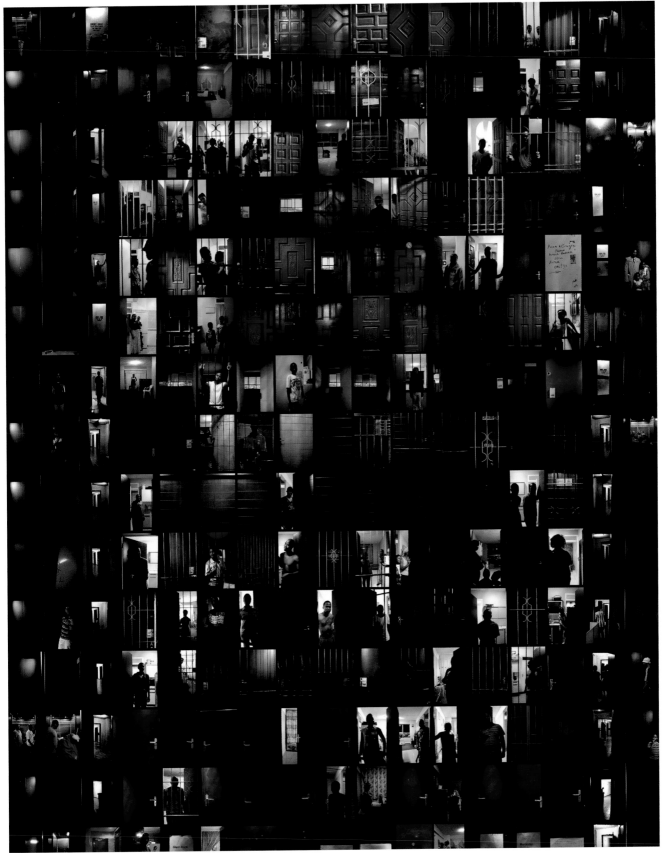

Doors, Ponte City (detail), 2008–10

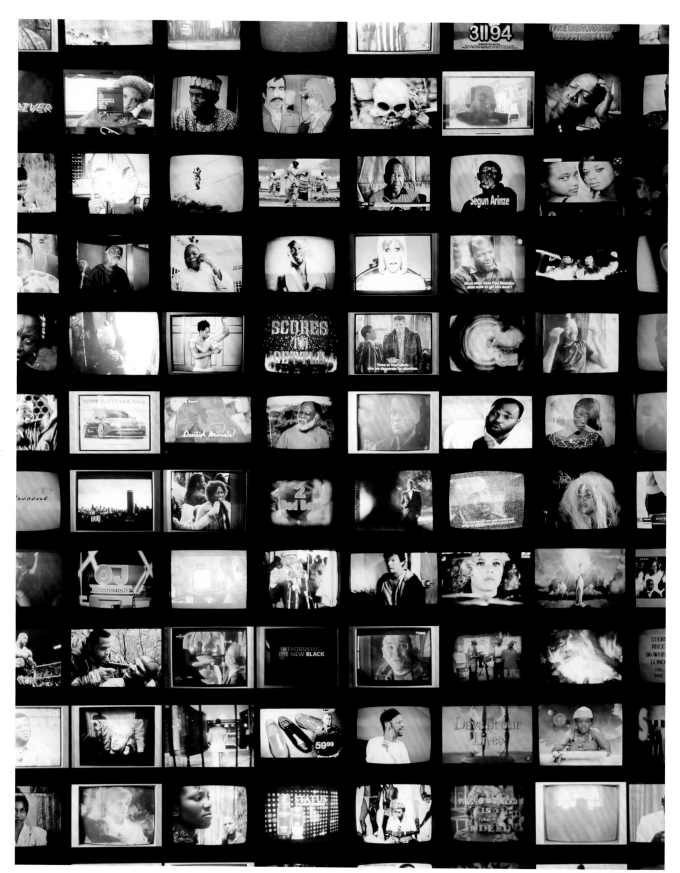

TVs, Ponte City *(detail), 2008–10*

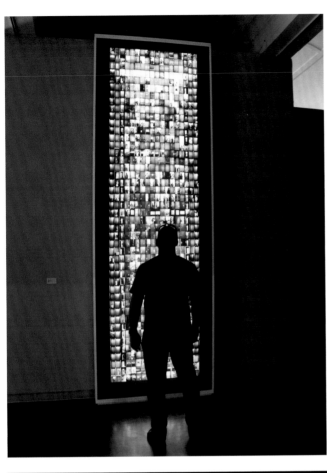

Doors, Ponte City, 2008–10

TVs, Ponte City (detail),
2008–10

Shimpei Takeda

Photographer Shimpei Takeda was born 40 miles from the site of the Fukushima Daiichi nuclear disaster of March 2011. An earthquake off the Pacific coast of Tohoku, Japan, caused a tsunami that resulted in the deaths of 20,000 people and disabled the power supply and cooling systems of three nuclear reactors. More than 100,000 people were evacuated from their homes because of concerns about radiation poisoning.

Takeda responded to the catastrophe with *Trace—cameraless records of radioactive contamination*, in which he exposed contaminated soil to photo-sensitive materials. The resulting autoradiographs, which appear to document solar systems, galaxies, or segments of star-strewn sky, are in fact impressions of the radiation emitted by contaminated particles of dirt.

This is not the first project in which Takeda has used cameraless techniques to record the physical imprint of a natural material. In *Salt Terrain* (2011–), for example, he created a series of cameraless works by placing salt on photo-sensitive paper and sprinkling water onto the surface. The resulting grainy images could document the surface of the moon, or a distant view of an ocean. In both series, Takeda's conceptual photograms capture something intangible and render it visible.

But *Trace* is concerned with more than process and aesthetics. Radiation levels are regularly measured and reported, but the numbers can feel like abstractions, whereas the results of radiation poisoning are anything but. Takeda has said that he sees this project as a way to document the disaster, and its aftermath, for future generations.

The soil samples for *Trace* were gathered from twelve locations in five different prefectures of northern Japan, including temple shrines, battle sites, and his birthplace, all sites chosen for their symbolic meaning and personal or national relevance. Takeda approached the project very methodically (as documented on his website, shimpeitakeda.com). He measured the radiation levels with a handheld Geiger counter. He placed sixteen different soil samples on 8x10 black-and-white sheets of film, then stored them in individual light-tight boxes. After a month, he developed the film.

In a note on his website discussing his fond memories of Fukushima, Takeda admits: "I wish I didn't have to face these prints." We might have the same wish, but these small, oddly beautiful photographs force us to consider the consequences of nuclear power on an intimate scale and in a tangible way.

Jean Dykstra

Born in
Sukagawa City, Fukushima Prefecture, Japan, 1982

Lives and works in
Brooklyn, New York

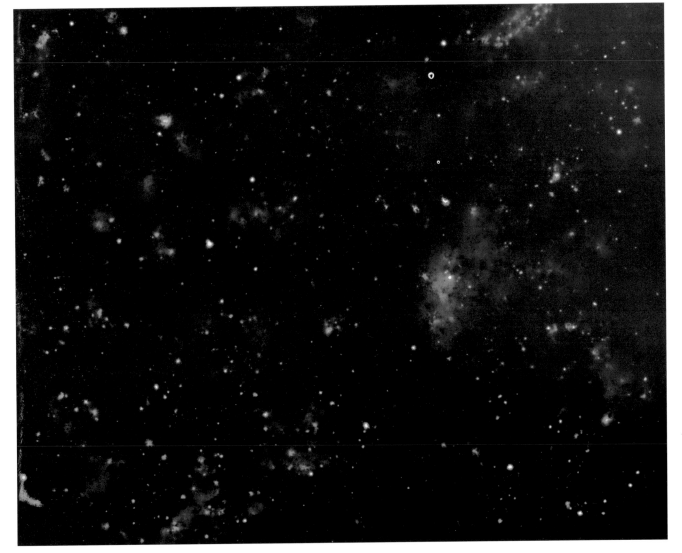

Trace #9, Asaka Kuni-tsuko Shrine, 2012

Soil Sample and Exposure Data
Collected Date: 1/4/2012
Weather: Sunny
Location: Koriyama, Fukushima
35.1 mi (56.5 km) W
Radiation Measurement:
Air 1.152µSv/h | Ground 3.780µSv/h
Film: Ilford HP5 Plus 8x10
Exposure Time: 1 month

Asaka Kuni-tsuko Shrine
This shrine was built in 135 A.D., when Asaka province was founded, and was dedicated
to Wakumusubi, a god of farming in Japanese mythology. In the late eighth century,
Sakanoue no Tamuramaro, a general in the imperial court, prayed for victories against
the native population, pushing them further north.

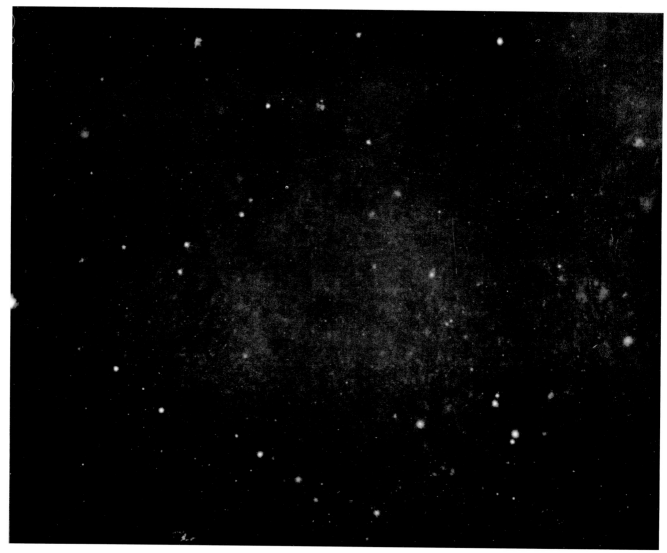

Trace #3, Former Kasumigaura Naval Air Base, 2012

Soil Sample and Exposure Data
Collected Date: 1/3/2012
Weather: Sunny
Location: Ami, Ibaraki
104.9 mi (168.8 km) SW
Radiation Measurement:
Air 0.415μSv/h | Ground 1.007μSv/h
Film: Ilford HP5 Plus 8x10
Exposure Time: 1 month

Former Kasumigaura Naval Air Base

Kasumigaura Naval Air Base was opened in 1922, focusing on flight education for pilots. The site is currently used by the Japan Ground Self-Defense Force. Dozens of World War II tanks are on display, and there is also a memorial hall exhibiting young pilots' portraits, notes, and belongings.

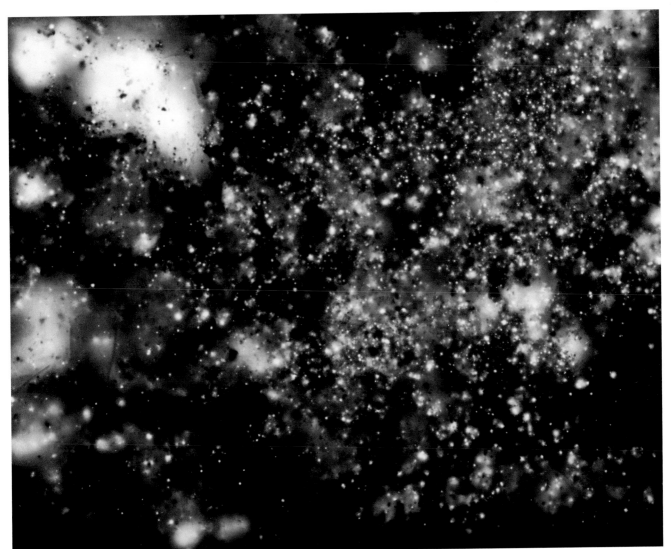

Trace #7, Nihonmatsu Castle, 2012

Soil Sample and Exposure Data
Collected Date: 1/4/2012
Weather: Sunny
Location: Nihonmatsu, Fukushima
34.7 mi (55.9 km) NW
Radiation Measurement:
Air 1.910µSv/h | Ground 4.299µSv/h
Film: Ilford HP5 Plus 8x10
Exposure Time: 1 month

Nihonmatsu Castle
Built in 1414, the Nihonmatsu Castle became an important site during the Boshin War (1868–69), a series of battles that led to the overthrow of the Tokugawa shogunate and the restoration of imperial rule in Japan. The Nihonmatsu Youth Corps, twenty warriors between the ages of twelve and seventeen, perished here.

Trace #10, Iwase General Hospital, 2012

Soil Sample and Exposure Data
Collected Date: 1/5/2012
Weather: Sunny
Location: Sukagawa, Fukushima
36.7 mi (59 km) SW
Radiation Measurement:
Air 0.363μSv/h | Ground 0.560μSv/h
Film: Ilford HP5 Plus 8x10
Exposure Time: 1 month

Iwase General Hospital

Opened in 1872, Iwase General Hospital was one of the earliest hospitals outside of Tokyo to introduce Western medicine. Records show that Meiji-era statesmen performed inspections there. I was born at this hospital more than a century later.

Trace #16, Lake Hayama (Mano Dam), 2012

Soil Sample and Exposure Data
Collected Date: 1/8/2012
Weather: Sunny
Location: Iitate, Fukushima
24.7 mi (39.7 km) NW
Radiation Measurement:
Air 1.848μSv/h | Ground 6.438μSv/h
Film: Ilford HP5 Plus 8x10
Exposure Time: 1 month

Lake Hayama (Mano Dam)
Built in 1991, the reservoir was once popular for black bass fishing. As a result of the nuclear meltdowns, the village of Iitate was evacuated by government order. Despite the immense beauty of the scenery, my Geiger counter clicked continuously.

Curators' Acknowledgments

We would like to express our gratitude first and foremost to the artists who have participated in this exhibition. It has been a pleasure to work with one and all.

The show would not have been possible without the generosity of ICP's Exhibitions Committee, which has supported the Triennial from its inception. Many thanks as well to Mark McCain and Caro McDonald/Eye and I, and Deborah Jerome and Peter Guggenheimer.

For their support and encouragement of this project, we are deeply grateful to Chief Curator Brian Wallis and Executive Director Mark Robbins.

As a large-scale international survey show, A Different Kind of Order: The ICP Triennial required the assistance, goodwill, and dedication of many people. We are grateful for the help of gallery and artist representatives, including Brandei Estes and Isabella Brancolini of Brancolini Grimaldi in London; Monte Clark in Toronto; Alissa Friedman, Victoria Keddie, Sarah Walzer, Salon 94, New York; Peter Blum and Renée Albada Jelgersma, Peter Blum Gallery; Tanya Leighton in Berlin; Tabor Story and Maxime Falkenstein at Barbara Gladstone; Shaun Caley Regen and Jennifer Loh at Regen Projects, Los Angeles; Michael Hoppen and Tristan Lund of Michael Hoppen Gallery, London; Kris Latocha and Jessie Washburne-Harris at Harris Lieberman Gallery, New York; Esther Kim Varet at Various Small Fires, Los Angeles; Manuela Mozo at Metro Pictures; Claire van Blerck at Goodman Gallery, Johannesburg; and Photios Giovanis at Callicoon Fine Arts.

A special commission from Triennial artist Rafael Lozano-Hemmer was not finalized in time to meet catalogue deadlines, but we want to thank Rafael for his unwavering enthusiasm, adaptability, and creativity in conceiving of a unique work for our Picture Windows series. Nica Ross' performances in A Different Kind of Order would not be possible without the collaboration of 3-Legged Dog. Alexandra Giniger and Virginia Wagner, at Wangechi Mutu's studio, Romain Lopez at Thomas Hirschhorn's studio, David Berezin, assistant to Trevor Paglen, and Eric Carroll in Jim Goldberg's studio were all especially helpful, as was curator Laura Barlow at e-flux. Designer Stuart Smith, SMITH International, collaborated with Gideon Mendel on our installation of Mendel's work.

An extraordinary team of interns worked on this project. Kelly Cannon put in long hours from the early stages, and made an indispensible contribution to the catalogue. We benefited greatly from the thoughtful research and energetic administrative assistance of Leigh Tanner. Jennifer Gerow provided crucial assistance in the final stages of exhibition planning. Haley Bueschlen, Dong Zhenjie, India Kieser, and Rebecca Walton O'Malley also gave their time generously.

We are grateful for the contribution of esteemed writers Jean Dykstra and Gregory Volk, and Margaret Ewing, who was also an invaluable research assistant. Deirdre Donohue, Stephanie Shuman Librarian at ICP, was an essential advisor on everything related to contemporary artists' book production, as was our colleague Matthew Carson, Associate Librarian and Archivist, and passionate co-curator of the book installation on view in the Triennial. We greatly benefitted from Siobhán Bohnacker's enthusiasm and knowledge about independent photo-book publishers, and are grateful for all her many donated hours.

Individuals who generously lent works to the show include Javier Macaya and Peter Blum. We are grateful to Ann Philbin, Director of the Hammer Museum, for the loan of Elliott Hundley's work, and to Portland McCormick, Director of Registration and Collections Management, for the swift and gracious assistance in transporting this large piece. Thanks also to Silvia Rocciolo, Curator, The New School Art Collection, for kindly loaning their Trevor Paglen work. For generous support of Nir Evron's participation in the Triennial, we are grateful to the organization Artis, with special thanks to Rivka Saker, and Mitchell Presser.

Many thanks go to visiting artist Titas Silovas for donating his considerable video/editing skills. For early research and consultation, we thank Isolde Brielmaier, Chief Curator, SCAD Museum in Savannah, Georgia; artist and educator Enrique Méndez de Hoyos; and journalist Jake Price, whose film featuring Shimpei Takeda brought the artist to our attention. We are also grateful for the thoughtful input of Gabriela Rangel, Sally Stein, Susan Bright, Sérgio Mah, Okwui Enwezor, Antonella Pelizzari, Clément Chéroux, and Thomas Seelig, Fotomuseum Winterthur, Zurich.

For every project, we rely on our dedicated, creative, and talented colleagues at ICP, and for an effort like

Photo Credits

the Triennial, their skills are all the more appreciated. Thanks to Production Manager Maanik Chauhan, Registrar Barbara Woytowicz, Exhibitions Assistant Africia Heiderhoff, Director of Marketing Kelly Heisler, and Publications Director Philomena Mariani; we thank Phil, also, for bringing the talented designer Maya Peraza-Baker on board. Thanks to our curatorial colleagues Erin Barnett, Cynthia Young, and Edward Earle. For collaboration on programming related to the exhibition as well as invaluable input and suggestions, thanks go to Phil Block, Suzanne Nicholas, Lacy Austin, Alison Morley, Marina Berio, and Nayland Blake. Thanks to Moira Ariev, Joe Ketner, and Becky Lipkind in our Development Department for their work on behalf of the project. The design of the exhibition was created by our deeply valued, longtime collaborators Alicia Cheng and mgmt. design. We had the new pleasure of working with installation designers Dan Wood and Amale Andraos, as well as Victoria Meniakina, of WORK Architecture Company on the physical transformation of our space.

Roy Arden Courtesy the artist, Brancolini Grimaldi, London, and Monte Clark Gallery, Toronto/Vancouver. Huma Bhabha Courtesy Salon 94, New York. Nayland Blake pages 31–33: Courtesy the artist and Yerba Buena Center for the Arts, San Francisco, pages 34–35: Courtesy Matthew Marks Gallery, New York. A. K. Burns Courtesy the artist and Callicoon Fine Arts, New York. Photos by A. L. Steiner (page 37), Katherine Hubbard (pages 40–41), and Gert Jan van Rooij (page 42). Aleksandra Domanović Courtesy the artist and Tanya Leighton, Berlin. Photos by Gunnar Meier (pages 46–47) and Hans-Georg Gaul (page 48). Nir Evron Courtesy the artist and Chelouche Gallery, Tel Aviv, pages 51 (bottom)–52 (left): Photos by Ruth Patir. Sam Falls Courtesy the artist. Lucas Foglia Courtesy the artist. Jim Goldberg Courtesy the artist. Mishka Henner Courtesy the artist. Thomas Hirschhorn page 81: Courtesy the artist, Galerie Chantal Crousel, Paris, and Gladstone Gallery, New York, pages 82–83: Courtesy the artist, page 84: Courtesy Stephen Friedman Gallery, London, page 85: Galerie Susanna Kulli, Zurich. Photos courtesy Romain Lopez (pages 81–83). Elliott Hundley pages 87–89: Courtesy Regen Projects, Los Angeles, and Andrea Rosen, New York, pages 90–91: Courtesy Regen Projects, Los Angeles. Oliver Laric Courtesy the artist and Tanya Leighton, Berlin. Andrea Longacre-White Courtesy the artist and Various Small Fires, Los Angeles. Gideon Mendel Courtesy the artist. Luis Molina-Pantin Courtesy the artist. Rabih Mroué Courtesy the artist and Sfeir-Semler Gallery, Beirut / Hamburg. Wangechi Mutu pages 127–29: Courtesy the artist and Victoria Miro Gallery, London, pages 130–31: Courtesy the artist and Susanne Vielmetter Los Angeles Projects. Sohei Nishino pages 133, 135–37: Courtesy Michael Hoppen Gallery, London, page 134: Collection Javier Macaya. Lisa Oppenheim pages 139–42 Courtesy the artist and Klosterfelde, Berlin, page 143: Courtesy the artist and Harris Lieberman, New York. Trevor Paglen Courtesy the artist, Altman Siegel, San Francisco, Metro Pictures, New York, and Galerie Thomas Zander, Cologne. Walid Raad Courtesy Paula Cooper Gallery, New York. Nica Ross Courtesy the artist. Michael Schmelling Courtesy the artist. Hito Steyerl Courtesy the artist. Photos by Ray Anastas and Leon Kahane (pages 370, 371). Mikhael Subotzky and Patrick Waterhouse Courtesy the artists and Goodman Gallery, Johannesburg. Shimpei Takeda Courtesy the artist.